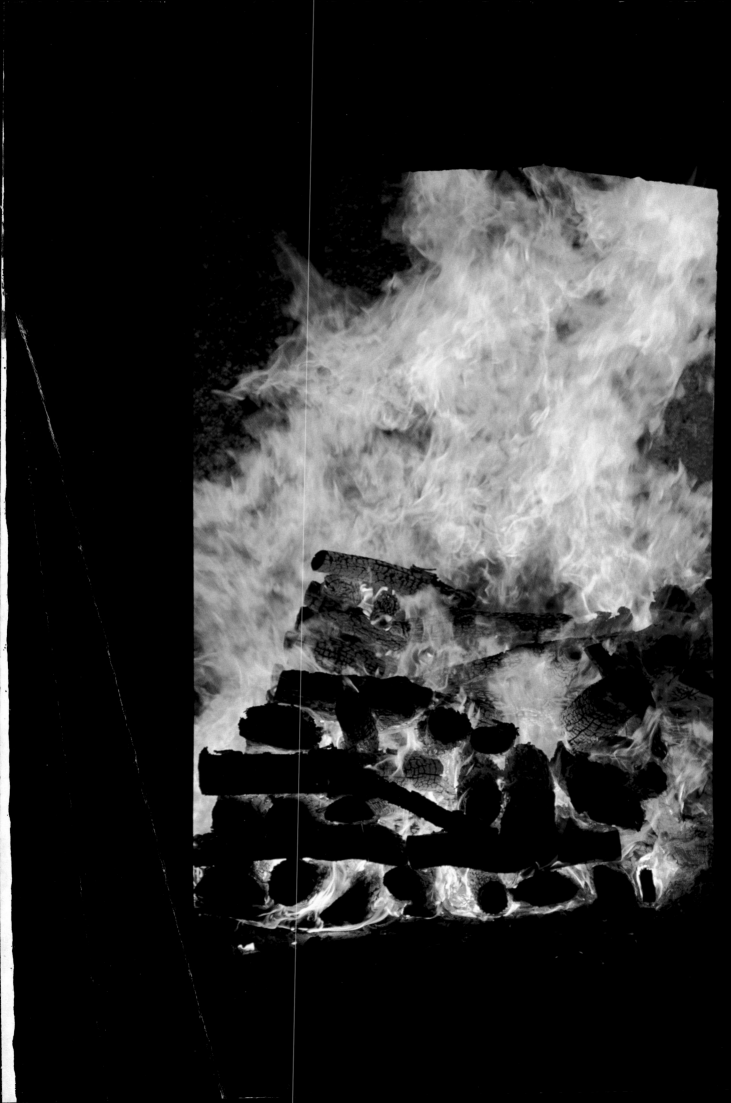

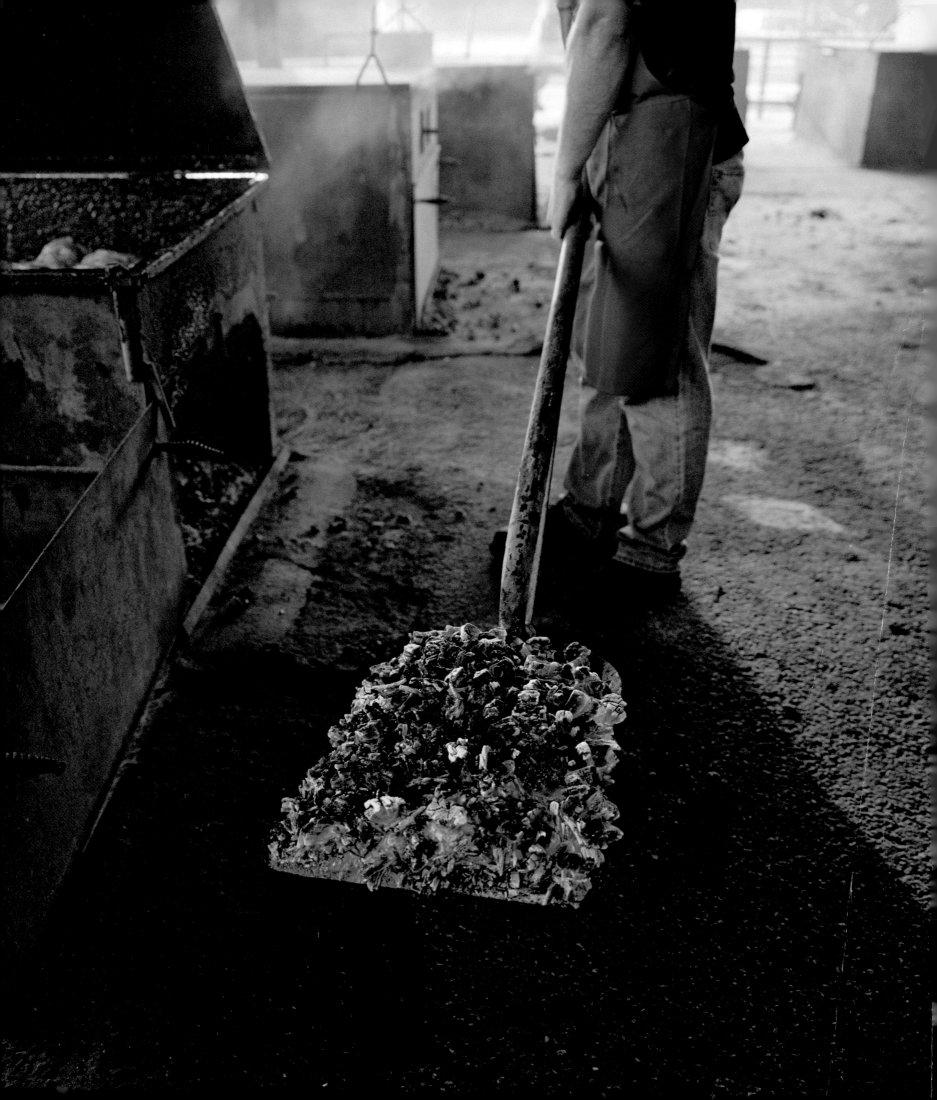

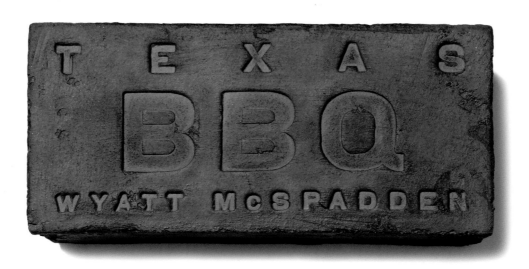

TEXAS
BBQ
WYATT McSPADDEN

TEXAS
BBQ

PHOTOGRAPHS BY

WYATT McSPADDEN

FOREWORD BY

JIM HARRISON

ESSAY BY

JOHN MORTHLAND

UNIVERSITY OF TEXAS
PRESS ✧ AUSTIN

NUMBER TWENTY-THREE
JACK AND DORIS SMOTHERS SERIES
IN TEXAS HISTORY, LIFE, AND CULTURE

Mesquite fire (P. 1) **: COOPER'S OLD TIME PIT BAR-B-QUE :** *Llano*

Red-hot coals (P. 2) **: COOPER'S OLD TIME PIT BAR-B-QUE :** *Llano*

German steel (P. 4) **: KREUZ MARKET :** *Lockhart*

Publication of this work was made possible
in part by support from the J. E. Smothers, Sr.,
Memorial Foundation and the National
Endowment for the Humanities.

Requests for permission to reproduce material from this work should be sent to:
Permissions
University of Texas Press
P. O. Box 7819
Austin, TX 78713-7819
http://utpress.utexas.edu/index.php/rp-form

♾ The paper used in this book meets the minimum requirements of ANSI/NISO
Z39.48-1992 (R1997) (Permanence of Paper).

Library of Congress Cataloging-in-Publication Data

McSpadden, Wyatt.
Texas BBQ / photographs by Wyatt McSpadden ; foreword by Jim Harrison ;
essay by John Morthland. — 1st ed.
 p. cm. — (Jack and Doris Smothers series in Texas history, life, and culture ; no. 23)
ISBN 978-0-292-71858-6 (cloth : alk. paper)
1. Barbecue cookery—Texas—Pictorial works.
2. Restaurants—Texas—Pictorial works. I. Morthland, John. II. Title.

TX840.B3M456 2009
641.5'78409764—dc22

2008035548

doi : 10.7560/718586

Book and jacket design by Nancy McMillen, Nancy McMillen Design, Austin, Texas

For Nancy, the soul of this project and the heart of our family.

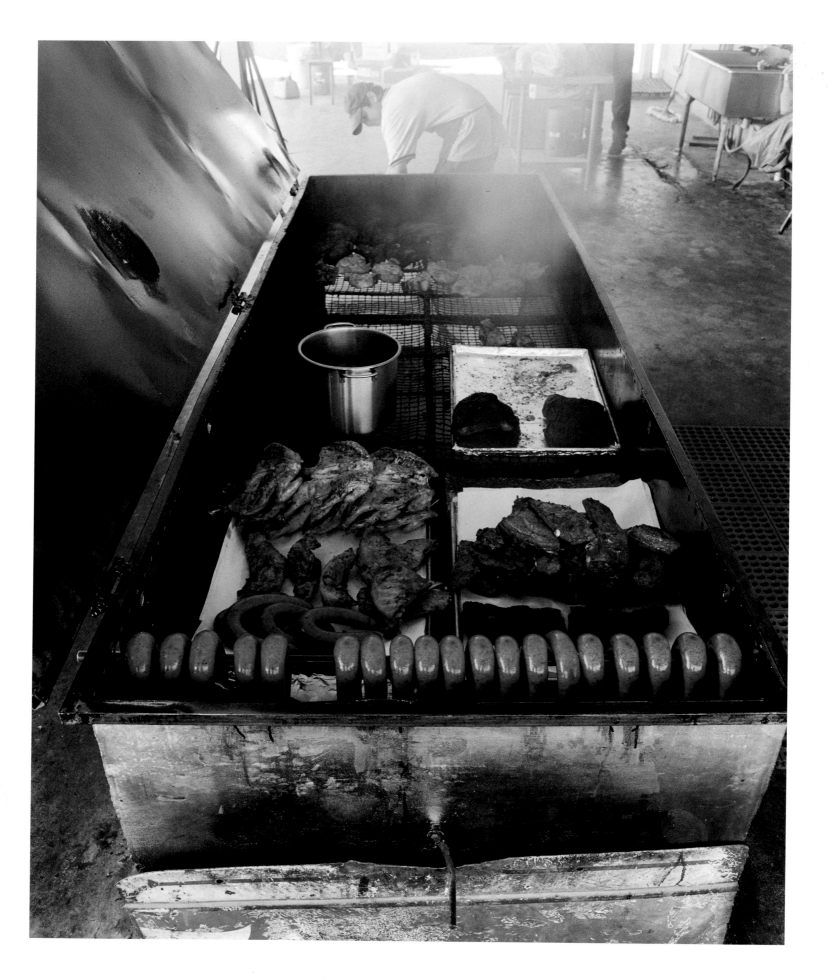

ACKNOWLEDGMENTS

To my parents: George, who taught me to go to work, and Betty, who nourished me and my siblings, Holly, Laurie, and Drew, with great food and music. To Trevor, for traveling with me on my earliest barbecue assignments. To Stuart, for falling in love with the Chop just like his old man did, and for helping me out on the final round. To Nora, for her wry sense of humor and for sharing her mom with me. To John Morthland and Charles Lohrmann, with whom I share a long and abiding love of both the Kreuz Chop and the drive to Lockhart. To Rick and Keith Schmidt and Roy Perez for making each Chop the best one ever. To Cilla McMillen for her encouragement and keen sense of language. To Annie Dingus for turning my raw text into real writing, and for her enthusiasm and efforts on behalf of this project. To fellow photographers O. Rufus Lovett and Michael O'Brien, whom I admire as artists and gentlemen. To *Texas Monthly* magazine and all the art directors who assigned the projects that started me down this path, especially the members of the quintessential art team: DJ Stout, Kathy Marcus, Hope Rodriguez, and Nancy McMillen. To Keith Patricio at API and Travis Smith at Holland Photo, for technical assistance. To Steve Sammons and Calumet Photographic for their special brand of support. To Robb Walsh for his essential books and articles on the subject of authentic Texas barbecue. To Dave Hamrick for his interest and guidance, and to the whole team at UT Press for their support. To Will Phillips, Robert Baumgardner, Matt Lankes, and Jeff Stockton for all the meals and miles we've shared. To Eddy Davis, whose enthusiasm for the Chop is genuine. To all my Clay-Kizer friends. To Erv and Linda Sandlin for all the years. To Stanley Marsh 3, who provided subjects, film, and chemistry. To Jim and Linda Harrison and Joyce Bahle for their generosity and their significant contribution to this book. To every client who ever hired me to do this thing that I love to do. And to all the folks at all the places I've visited and photographed: *Thank you.*

Cowboy-style pit : **COOPER'S PIT BAR-B-Q** : *Mason*

Vision and Memory
by Jim Harrison

It is odd to consider that within a millisecond everything we see becomes memory. It wasn't until my twenties that it occurred to me that my single eye was an aperture, the other was lost to a childhood accident, and by blinking this aperture I could embed certain images forever in my neurons and recapture the images when I so chose, and thus have an immense photo gallery in my head. These mental photos can vary from a lioness in Kenya reaching down a warthog's hole and uprooting the beast for lunch, to a carp wallowing in the shallows of the Neva River outside of St. Petersburg, to a girl changing into her bathing suit in the backseat of a Mercedes limousine on a hot afternoon in Rio de Janeiro.

The trouble is my mental photos fail aesthetically. I mean the eye can be a monster camera through which we frame our visual life but this is a private rather than an artistic affair. The camera, like the typewriter, is a matter of technology and we have produced billions of photos and billions of pages but by common consent to all except dullards it all depends on who is manning the typewriter or camera. I don't really want to look at Aunt Dottie's ten rolls of snapshots from Honolulu.

When I first looked at Wyatt McSpadden's photos I fancied that someone had given the soul of Edward Hopper a camera and sent him off to Texas. I won't push this comparison any further than the beauty and starkness of the images because I don't recall Hopper ever painting something you could eat and the contents of McSpadden's book made me quite wild with hunger beyond consideration of his obvious genius as a photographer.

Let me back up a bit. Years ago in the eighties I was in Nebraska researching a novel to be called *Dalva*. I read a great deal on the history of the Sandhills and drove thousands of miles but it wasn't until I visited the vast photo collection at the Nebraska Historical Society that I came close to truly understanding the past. The curator, John Carter, guided me through the years, county by county, through thousands of photos which though mostly harmlessly inept added immeasurably to the lives of the characters I had imagined. Occasionally a photo would transcend its snapshot limitations: an elegantly dressed old man standing before his mansion in Omaha with several coyotes on leashes, two Indians dancing in the foreground while men looking at cows ignore them, the daughter of William Jennings Bryan jumping over a high hurdle while wearing the very proper twenty pounds of clothing.

To a certain extent we become what we see. It is a large part of the contents of our lives. A photograph when it reaches the condition of art becomes as permanent as a fine painting. Our lives are properly a search for the genuine and we unfathomably enrich ourselves by nearly suffocating ourselves in fine music, art, literature and photography. After a dozen trips to Mexico over the years my perception of Mexico was added to immeasurably by reading *The Labyrinth of Solitude* by Octavio Paz and studying the photography of Graciela Iturbide. She enabled me to see to a magnum level what I had already seen with my very modest visual abilities. Last year when my friend Drum Hadley, owner of the vast Gray Ranch, published his lifelong collection of poems centered on ranching and cowboying, *Voice of the Borderlands,* I could *see* the book because I had spent a great deal of time with Bill Wittliff's *Vaquero: Genesis of the Texas Cowboy* including the wonderful introduction by John Graves. When you look up at the neutral wall from Wittliff's photos you smell hot dust, blood, horses and cattle. This kind of *seeing* leads to full understanding which is negatively demonstrated by the idea that Congress passes laws on migrants without the

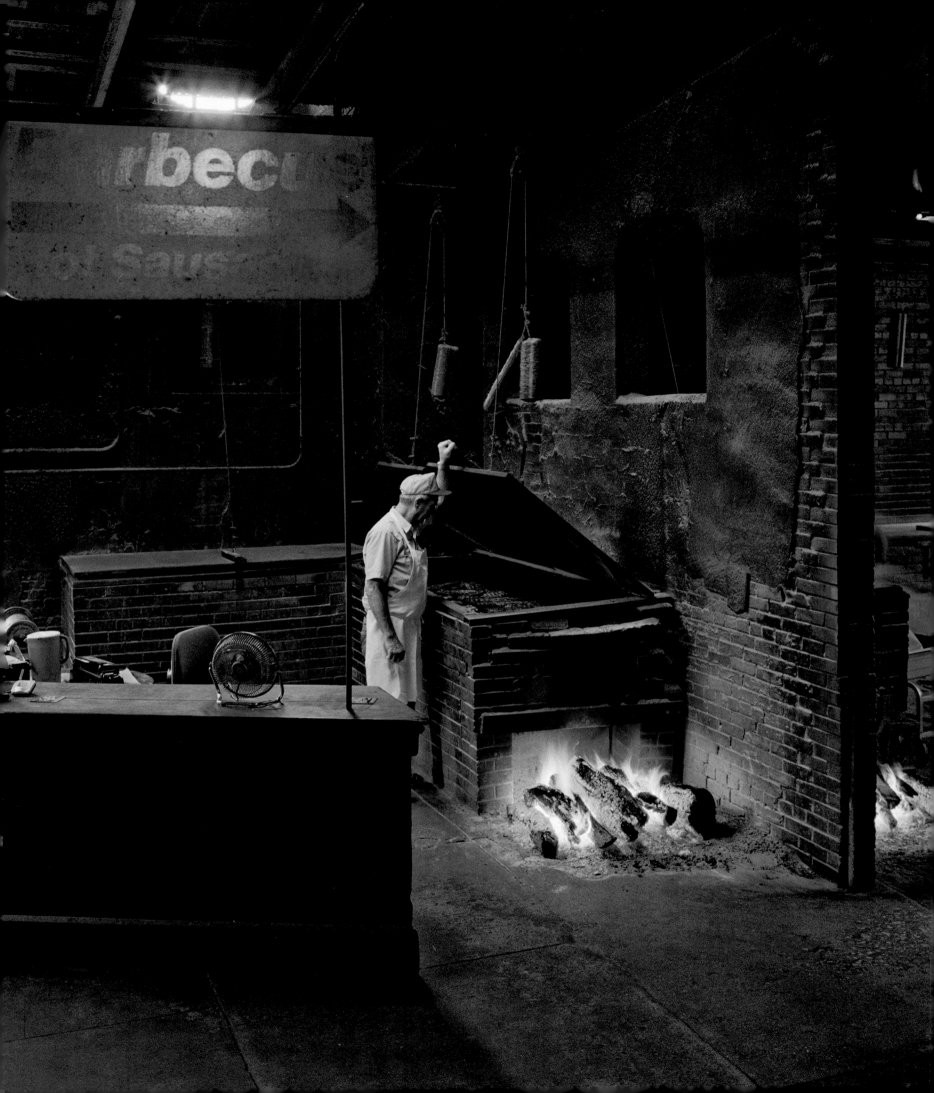

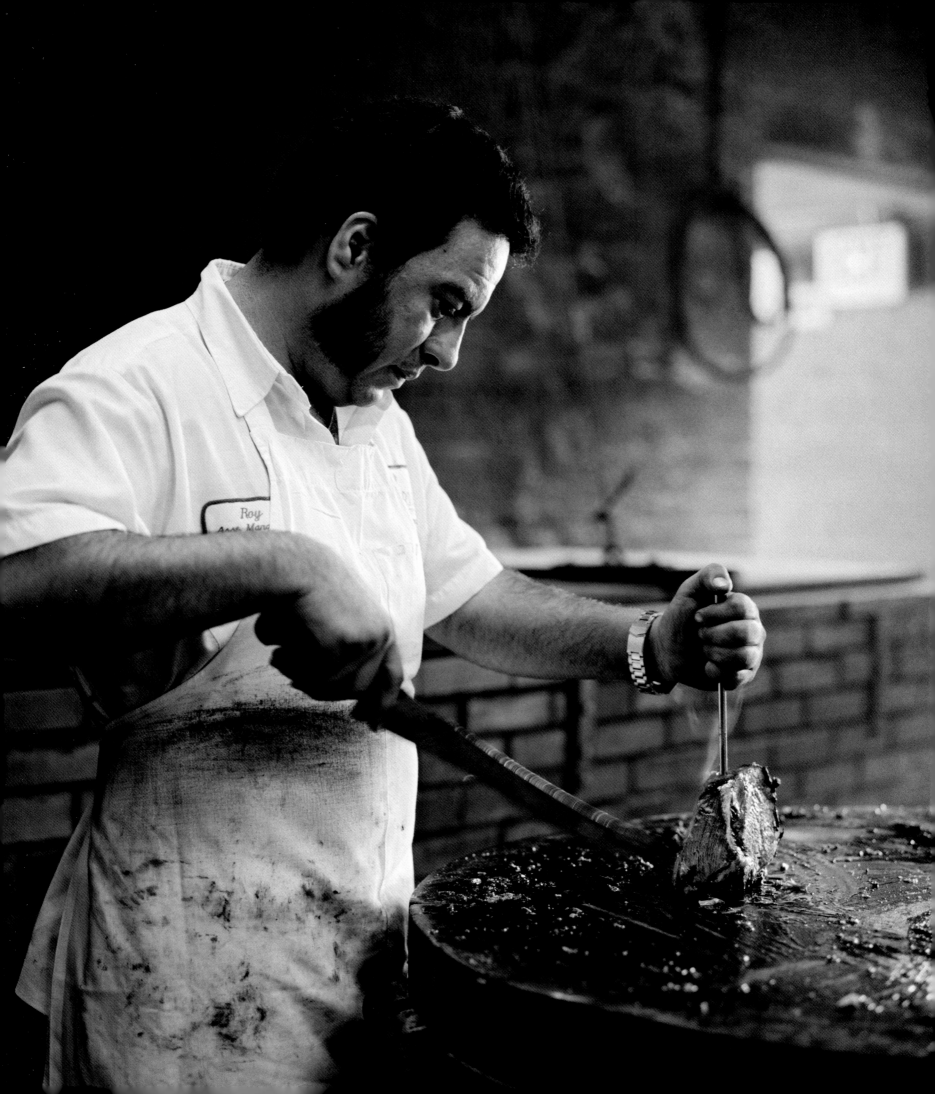

great majority of them ever having seen any of our nearly two thousand miles of border. Or imagine a great war photographer like Robert Capa accepting the moratorium on photos of caskets when they are the dominant fact of war.

Wyatt McSpadden's work has a special poignancy to me beyond its obvious aesthetic qualities, the depth and resonance of the images, the captivating use of darkness that becomes almost livid. After a full afternoon's viewing of McSpadden I thought for a few moments of not categories but a certain interior continental drift in the arts. In poetry you have the somewhat icy formalism of Wallace Stevens and the photography of Edward Steichen or Paul Strand arousing similar feelings but you also have the preposterous impurity of Pablo Neruda in which men and women are traditionally romantic but are also allowed to yowl like alley cats. You actually feel rather sexy after reading Neruda even though you're seventy years old like myself.

The work of Wyatt McSpadden is clearly on the side of Neruda. Perhaps I responded so strongly to McSpadden because that's also where I find myself as a poet, a novelist, an intensely mediocre screenwriter, and the author of a book on food called *The Raw and the Cooked*. I have been cautioned by a *mind doctor* to stop trying to eat the world in all of its aspects. McSpadden as a photographer is a devourer and in this book you can smell the photos even when no food is present. Many of the photos are somber enough to make you re-think food as a sacrament and those who man the barbecue pit as priests of a holy substance, but this is not a church that has been built but one that grows out of the earth where we weary mammals may stop to be restored. We are never as far as we may think from a short amateur film I saw in which a grizzly bear ate a fresh elk kill. After taking an antelope I can't wait to get home to sauté the liver and heart. The skulls beneath our faces are clearly mammalian and it is not unthinkable that the future

will find me camped out in Lockhart, Texas for a week so that I may twice a day visit Kreuz Market and restore the energies that the culture so gracelessly beats out of us. It will be fun to eat at a place where both yogurt and portobellos are unavailable and, where some culinary school nitwit hasn't devised a jícama-pomegranate salsa.

I had seen a selection of McSpadden's photos last summer in Montana and grieved over the geographical unfairness that Montana has chicken-fried steak and no pit barbecue while Texas has both. In November I spent two weeks in France driving around with a friend taking on nourishment and amply hydrating with French wines. While I was in Lyon being awarded an unwearable two-pound medal that I gave my grandson to use as a paperweight, I thought about the photography of Wyatt McSpadden. It occurred to me in one of the twenty-eight old classic bistros in Lyon that very little of the food photography in American magazines is truly representative except for layabouts with fat wallets, the intent being to pique the interest of those who aren't actually hungry. There are those wildly colored little towers of food one wishes to tip over with a snap of the fingers but then America has many deranged and puritanical misapprehensions about food and there is an urge among art directors of food magazines to make it look like a floral arrangement in a painting at a small town art fair. In Lyon when you order beef muzzle in a vinegar sauce it looks like it came from a cow's nose and is not destined to be photographed. The same with St. Cochon which is a little piglet cooked five different ways. And the rather gelatinous mass of *tête de veau* (the cheeks, tongue, and neck meat of a calf with a *sauce gribiche*) is the emotional equivalent of Texas pit barbecue. What I intensely mean here is the photography of Wyatt McSpadden returns us to the earth where most of us actually live and does so with permanent grace. It revives us.

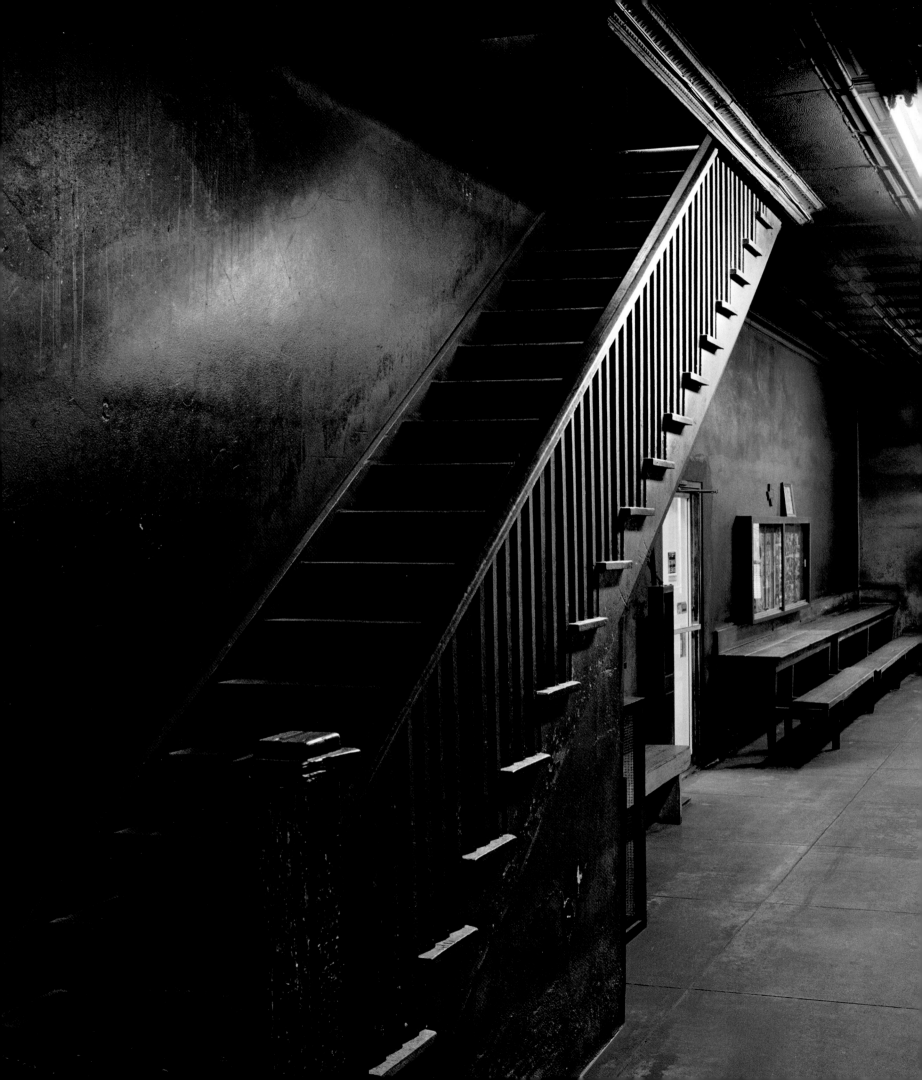

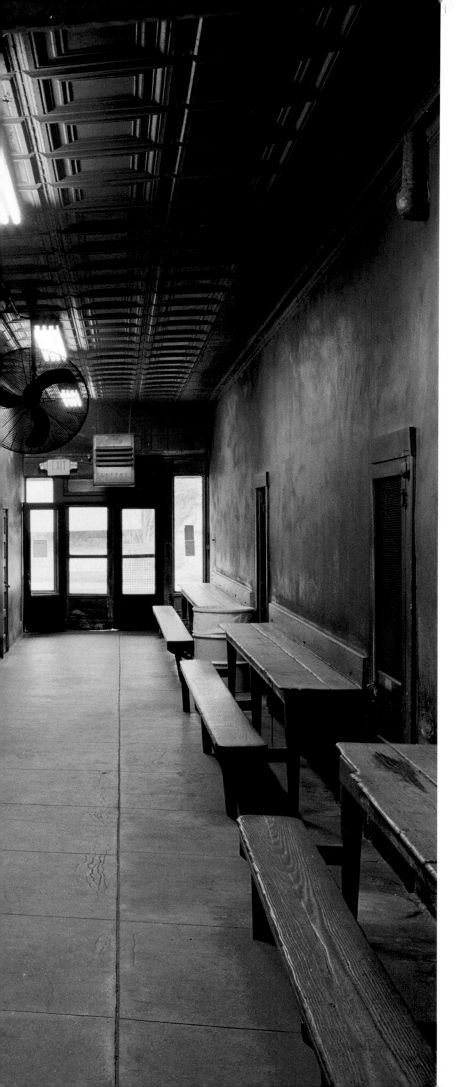

Old dining room : **SMITTY'S MARKET** : *Lockhart*

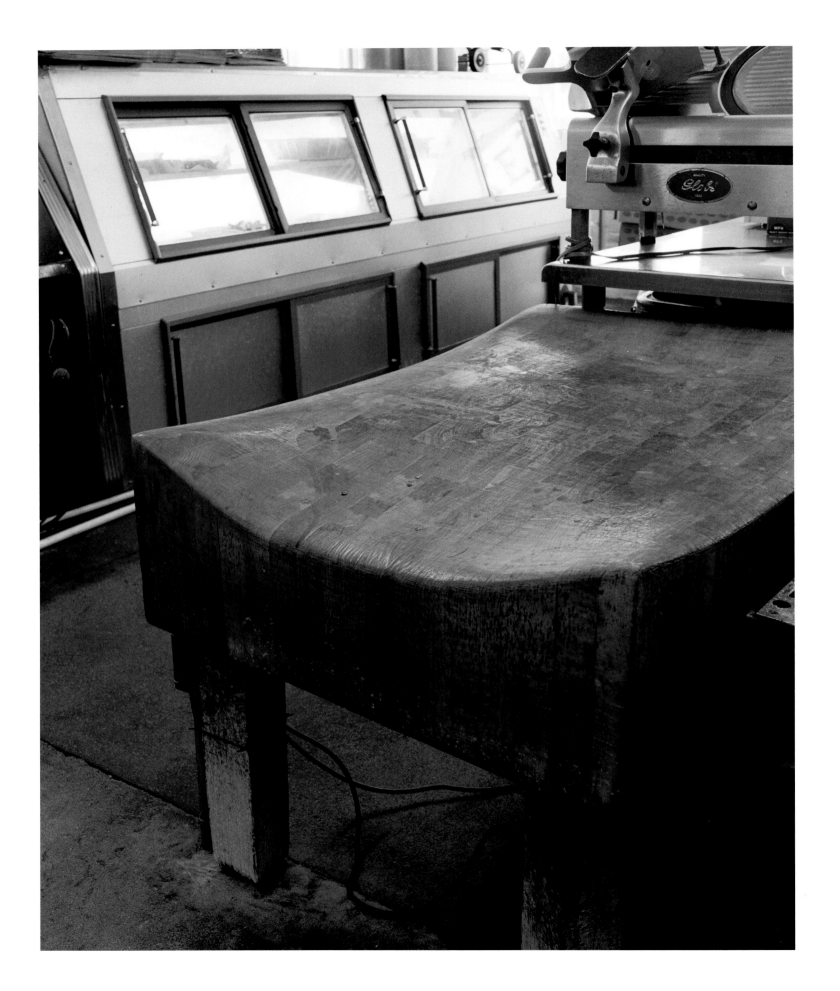

THE MEAT OF THE MATTER

I grew up in a grocery store in Amarillo. My dad and his brother took over the family business from their father when they returned from World War II. In 1962, when I was ten years old, I started going to work with Dad on Saturdays. I carried around a milk crate to stand on so I could work produce or bag groceries, my apron rolled up so I wouldn't trip on it. The store was a marvelous place for a little kid, but the best part, the heart of it, was the meat market. Central Grocery was known around town for its fine meats, and the star of the operation was the butcher. The butcher was special: he didn't sack groceries, run the register, trim the lettuce, or stock the shelves. The meat market was off limits to me—its floors were slick, the knives were sharp, and the butcher was not to be disturbed.

One butcher stands out in my memory: Harold Hines. I was in my early teens when Harold came to us and first allowed me to set foot in his hallowed domain. Everyone said Harold was a really good butcher, and though I can't say if that was true or not, I do know he was friendlier with the customers and with me than most of his predecessors had been. Once or twice a month, on a Saturday, Harold would make barbecue. That's what he called it, although it was something he prepared in a big electric slow cooker in the meat market. I loved it—the smell that filled the store, the little cardboard bowls he'd give me to sample— lunch with soda crackers and longhorn cheese. The aroma drew folks to the market. Harold was a star.

While working on this collection of photographs, I've often thought about Central Grocery. Traveling around the state looking for the "right" kind of barbecue places to photograph, my inner sack-boy was reawakened. Some of the places I visited weren't so different from Dad's store. Prause's Market in La Grange, with the beautiful Friedrich refrigerated cases made in 1952, the year I was born; Gonzales Food Market, where the manager, Maurice Lopez, still wears an apron and paper hat from a bread company; Dozier's Market in Fulshear, with a modest display of canned goods and paper products standing between the entrance and one of the most eye-popping selections of meats I've ever seen. What these places have that Central Grocery didn't is real wood-smoked barbecue, made out back in brick pits fueled by post oak, pecan, and mesquite.

Many of the barbecue places I visited started out as meat markets. Kreuz Market in Lockhart, Novosad's in Hallettsville, and City Market in Luling still display vestiges of their butcher shop heritage, even though these days the house specialty is smoked meats. Over time the process of creating pit barbecue has transformed such modest spots into great spaces, where the smoke and heat have penetrated the walls and the people who toil within them. To me these are magical places. Part of the magic is in the food; part is the fact that I was always made to feel welcome. Whether I called in advance or dropped in unannounced, I was, without exception, free to shoot whatever interested me. How rare a thing that is in these times, and I am most grateful. These pictures are my thank-you to all the wonderful folks, all the Harolds, who let me inside their lives and who took the time to stand for me, or open a pit, or stoke up a flame.

Wyatt McSpadden

**Butcher block : CITY MEAT MARKET : ** *Giddings*

James Holland shoveling hot coals

COOPER'S OLD TIME PIT BAR-B-QUE : *Llano*

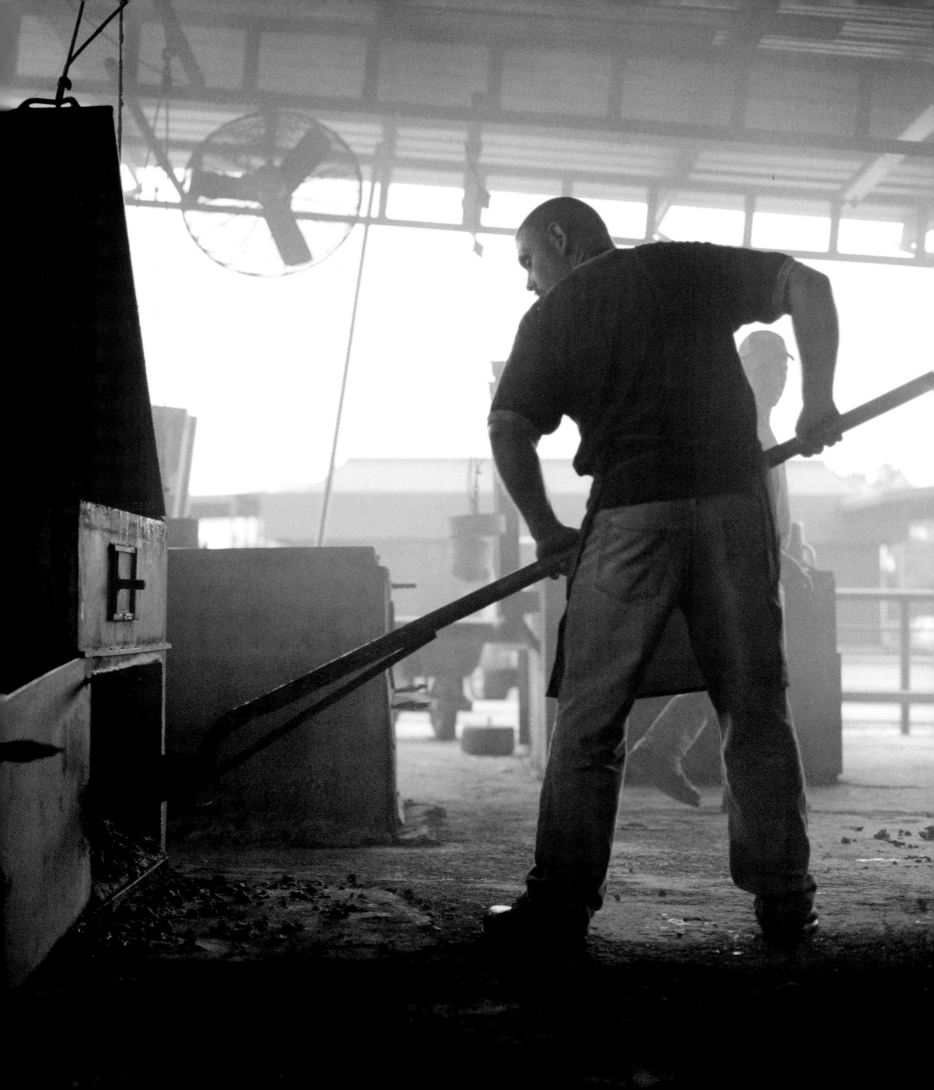

Pit doors *SONNY BRYAN'S SMOKEHOUSE* (INWOOD LOCATION) * *Dallas*

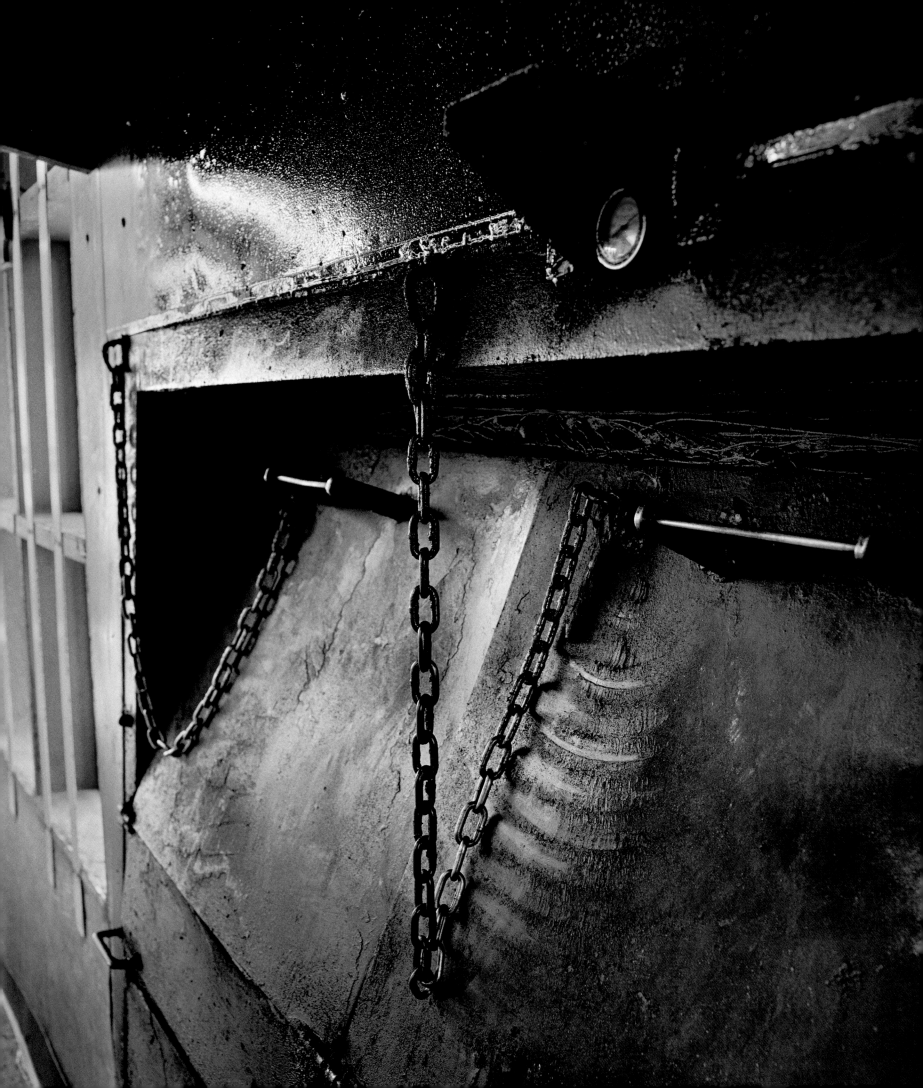

"TEXAS BARBECUE IS BETTER THAN BARBECUE EVERYWHERE ELSE, BECAUSE— WELL, GOD IS A UT FAN AND HE'S FROM TEXAS, 'CAUSE HE MADE ALL THIS MESQUITE WOOD. YOU GOTTA HAVE A GOOD MESQUITE WOOD TO MAKE GOOD BARBECUE. AND OF COURSE YOU GOTTA HAVE GOOD MEAT BEFORE YOU CAN DO ANYTHING AT ALL."

KENNETH LAIRD, 61, PITMASTER 32 YEARS, LAIRD'S BARBECUE

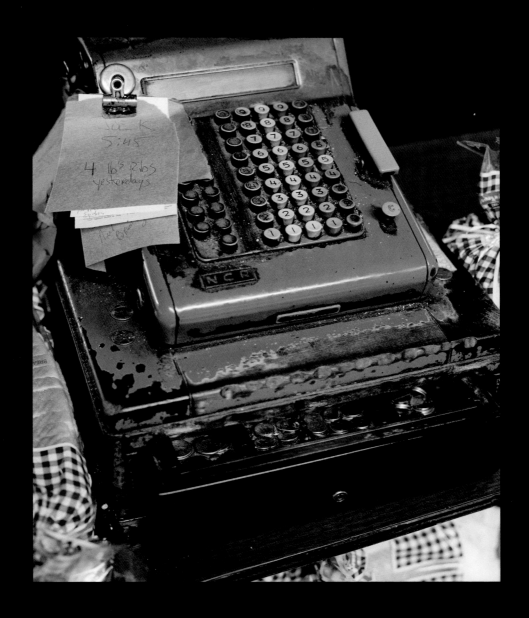

LOUIE MUELLER BARBECUE : *Taylor*

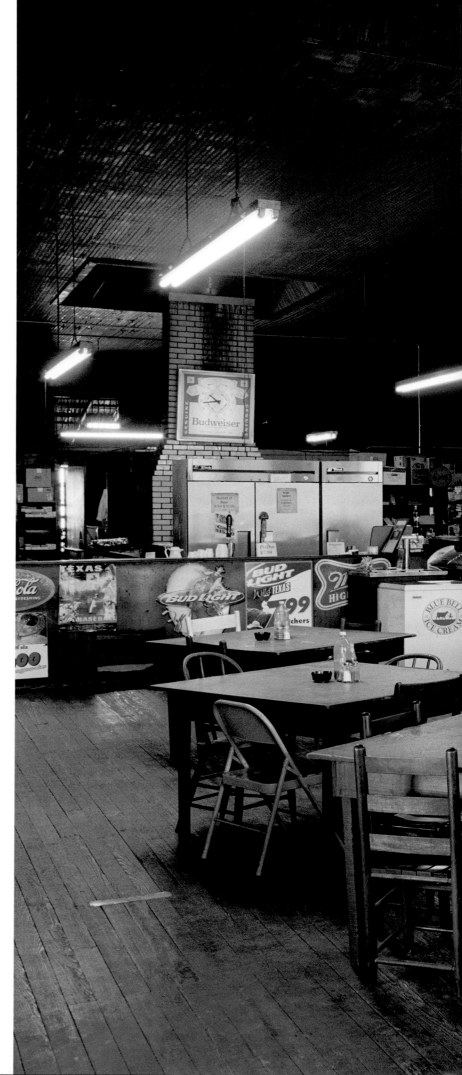

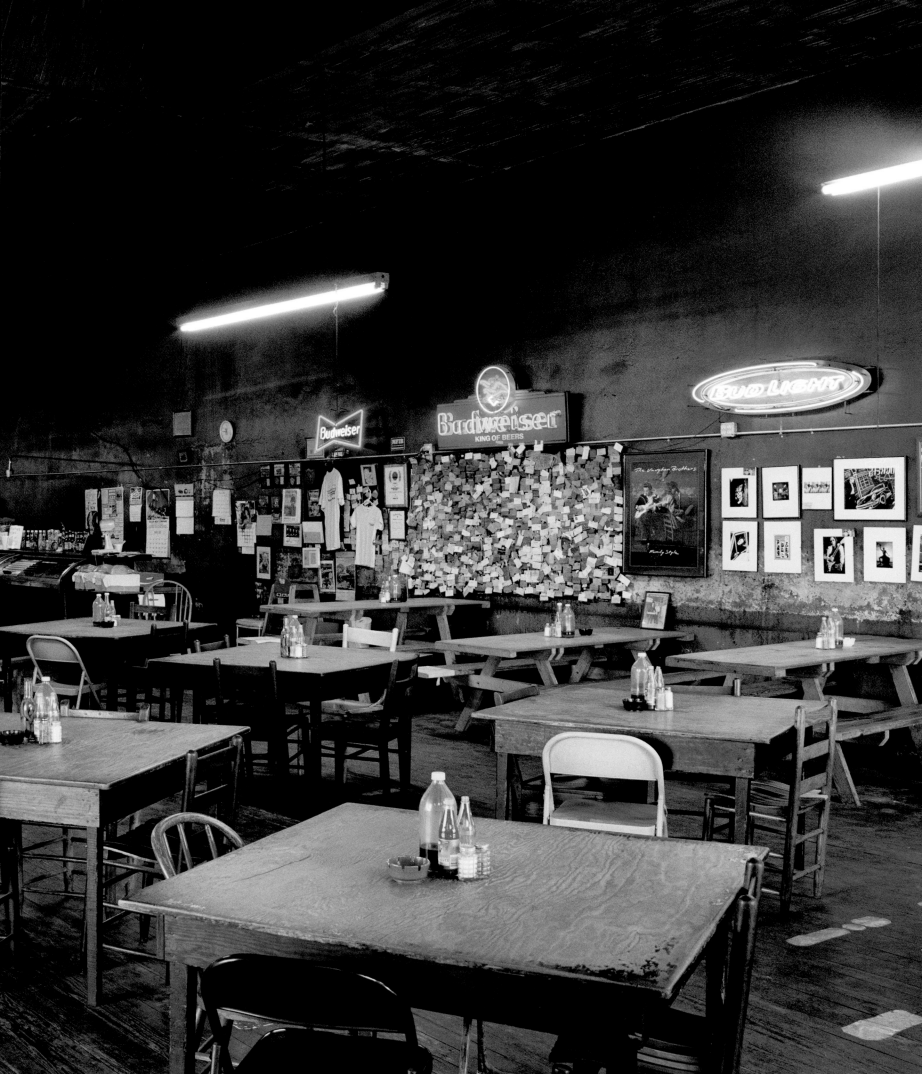

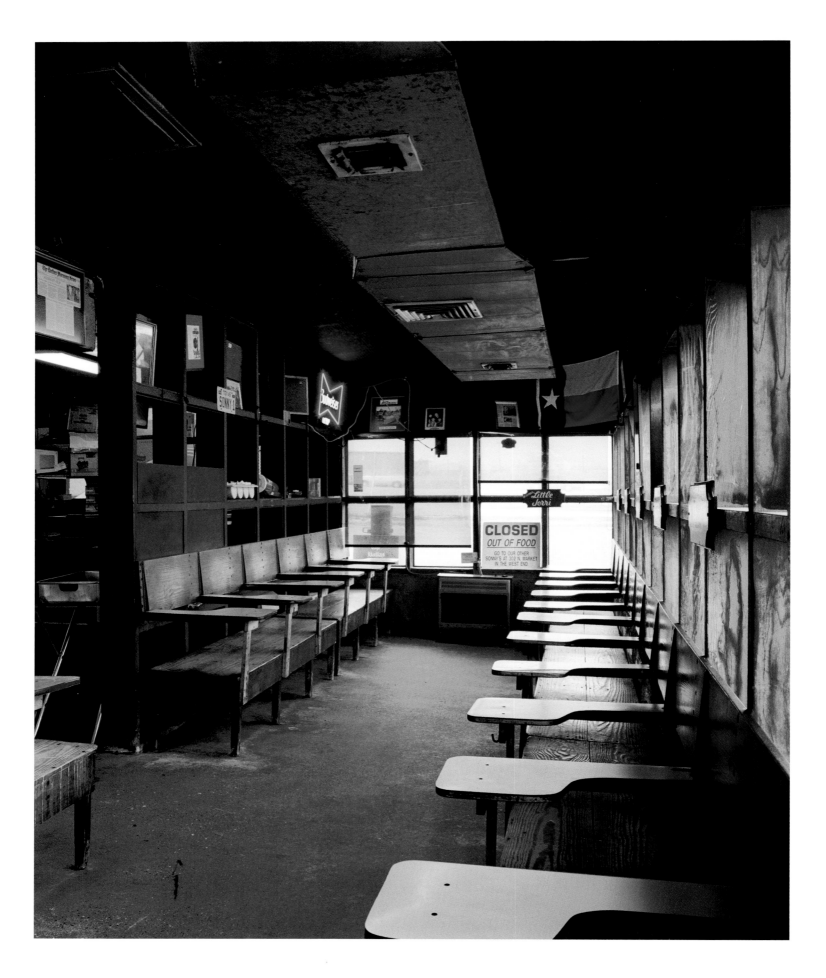

Lunch room : **SONNY BRYAN'S SMOKEHOUSE** (INWOOD LOCATION) : *Dallas*

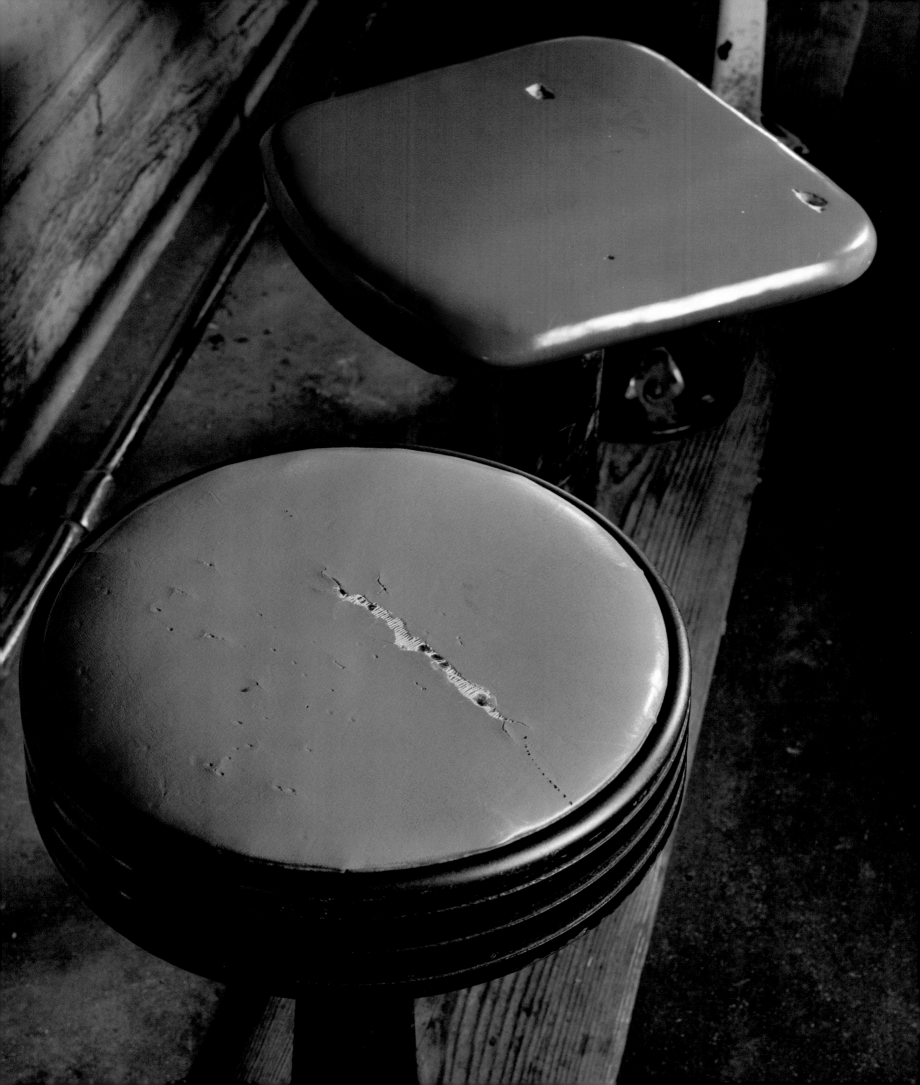

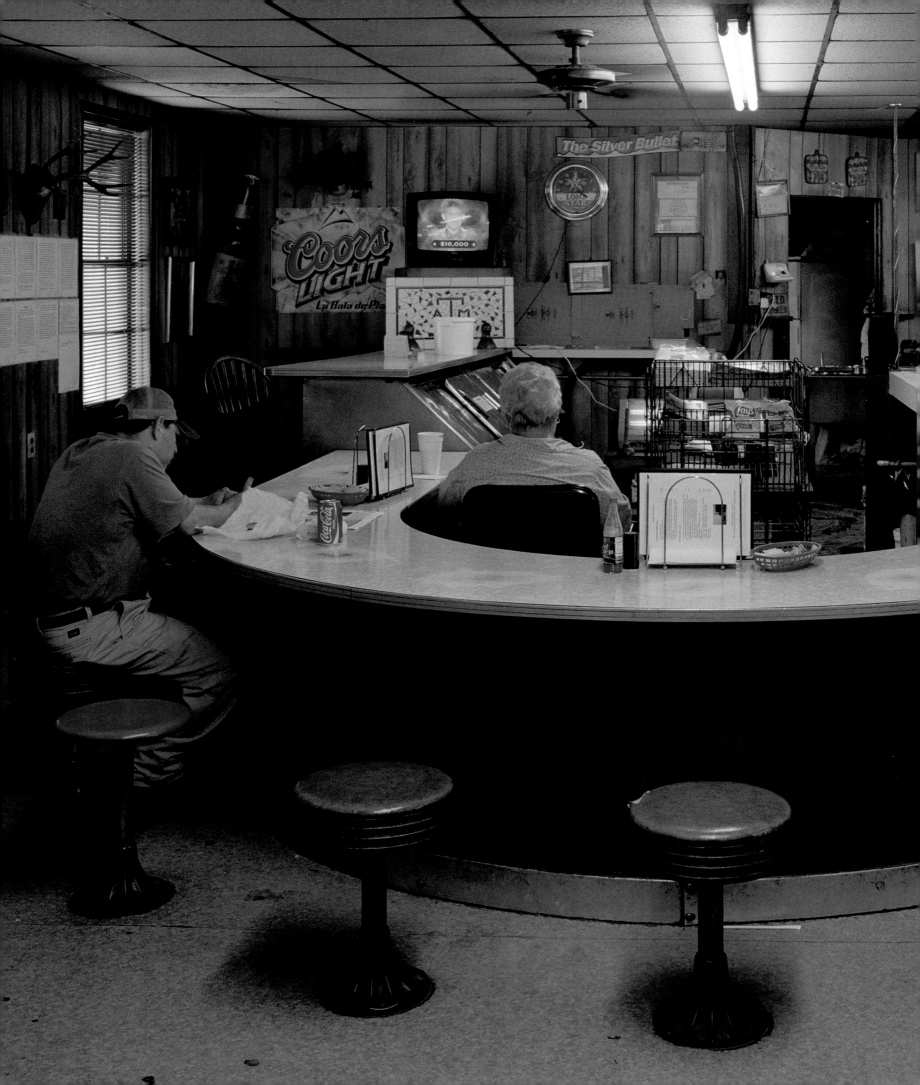

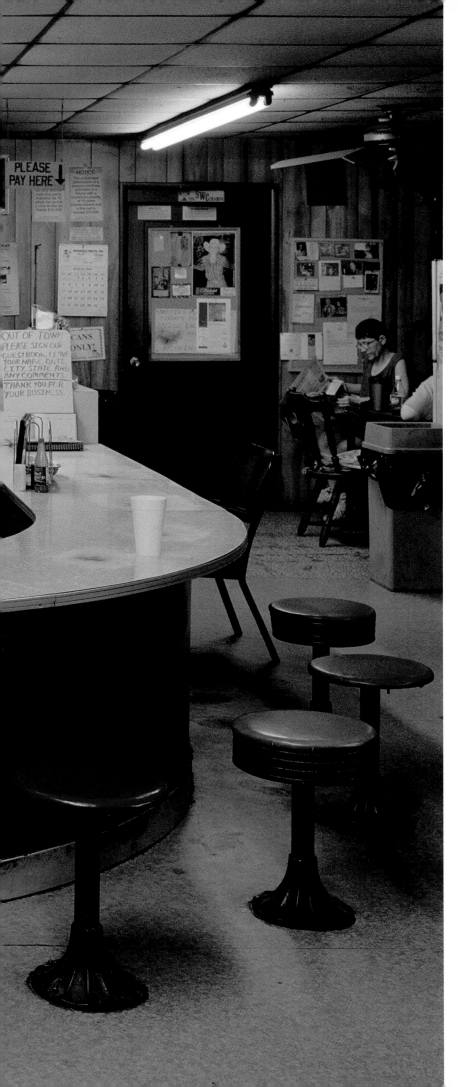

Counter : **MARTIN'S PLACE** : *Bryan*

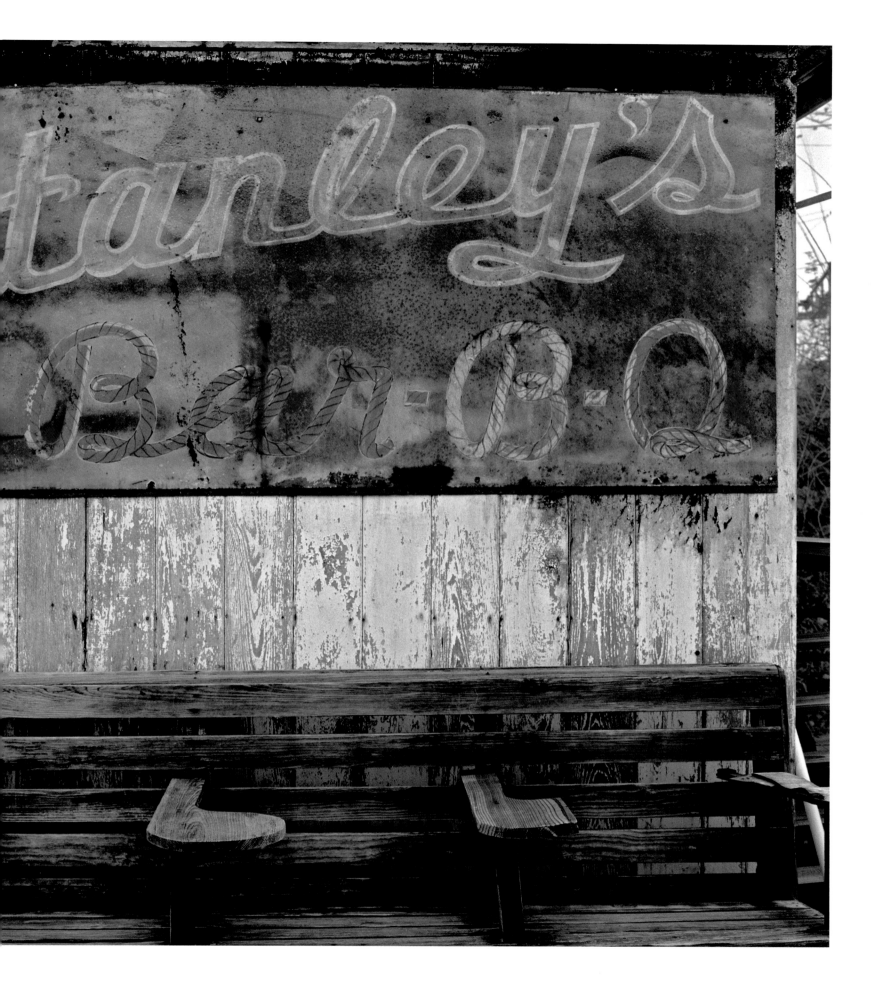

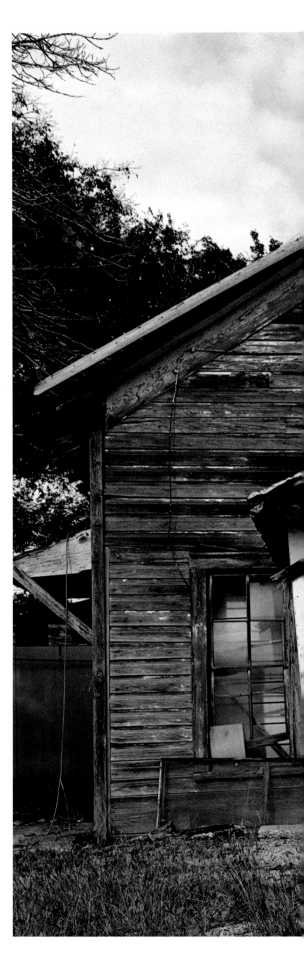

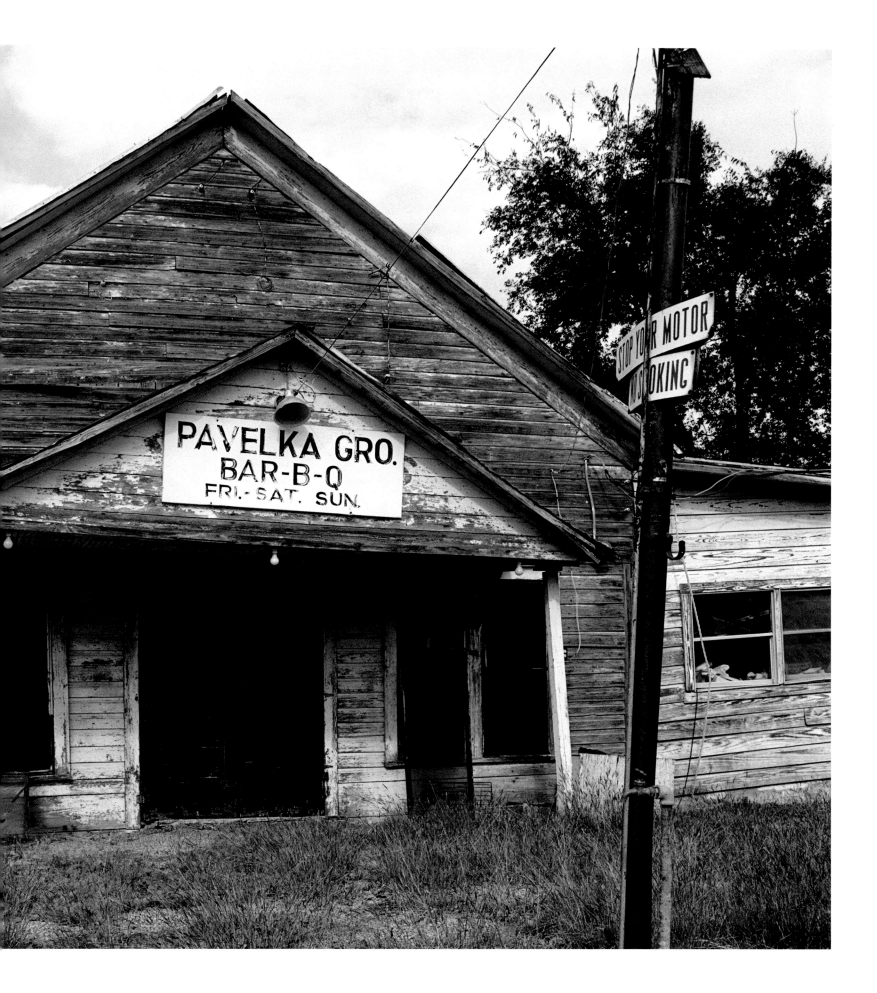

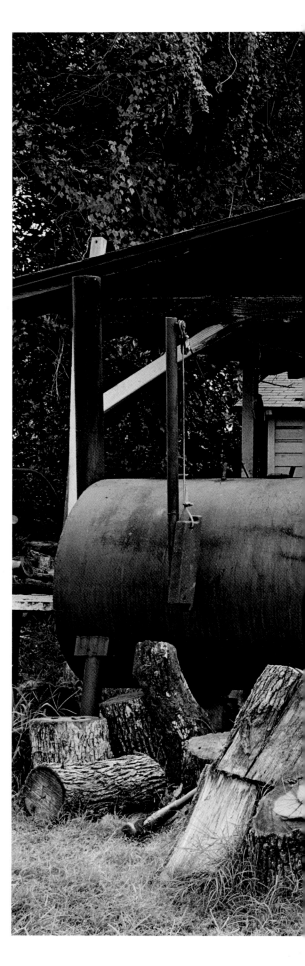

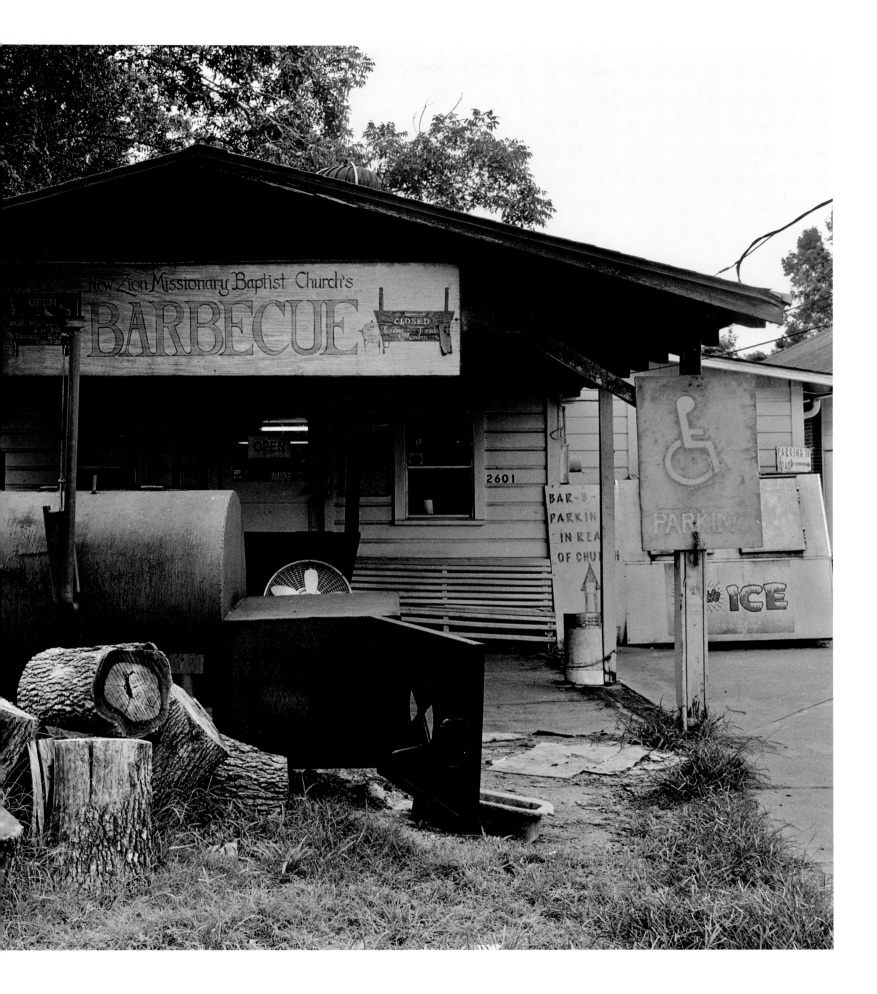

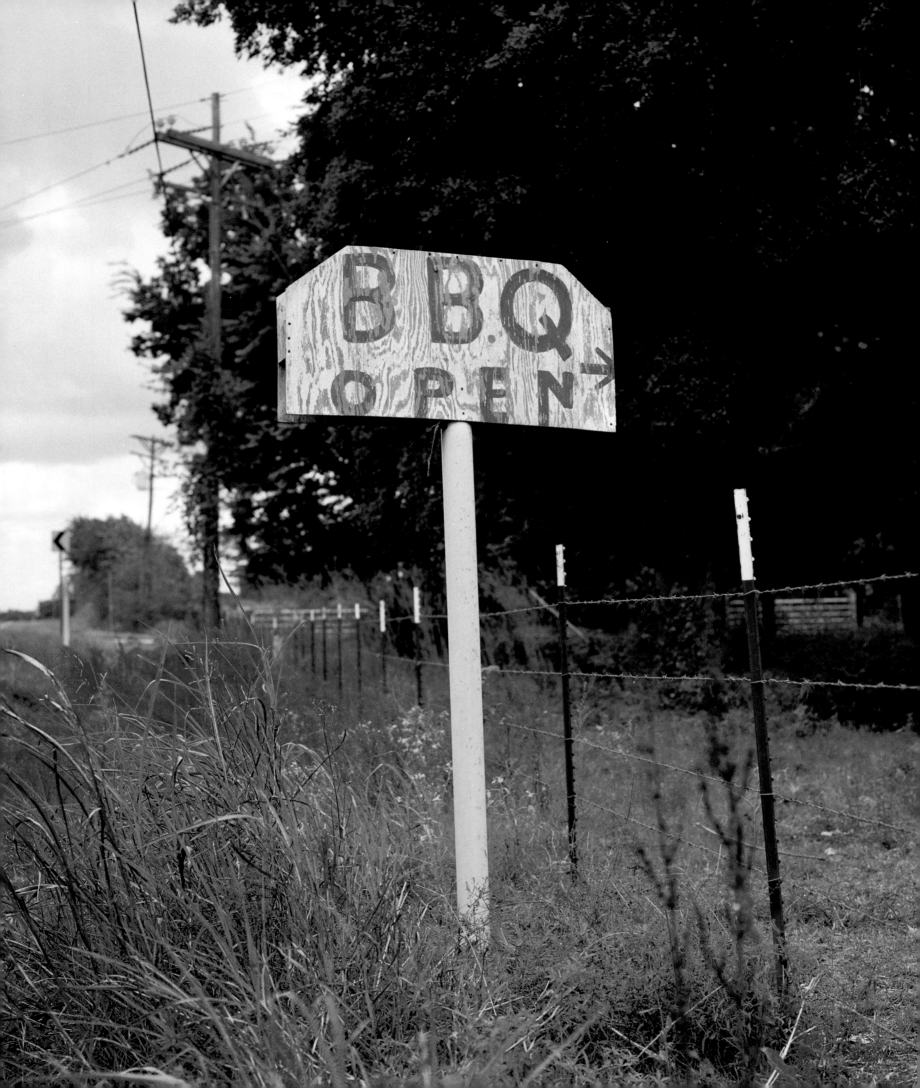

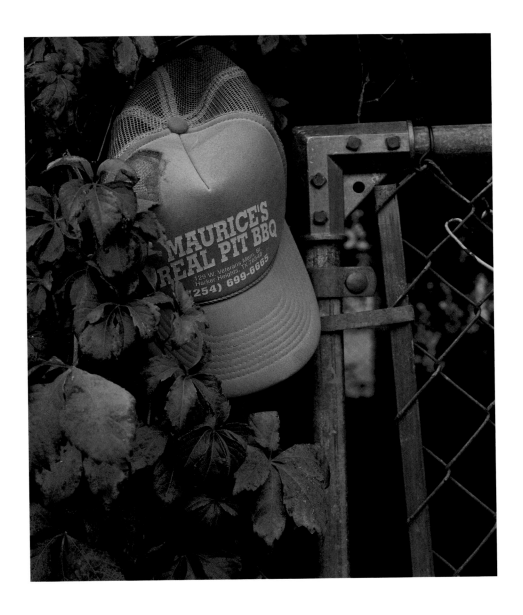

Gimme cap : **MAURICE'S REAL PIT BBQ** : *Harker Heights*

◄ Weathered sign : **RUTHIE'S PIT BAR-B-Q** : *Navasota*

Neon sign : **SONNY BRYAN'S SMOKEHOUSE** (INWOOD LOCATION) : *Dallas*

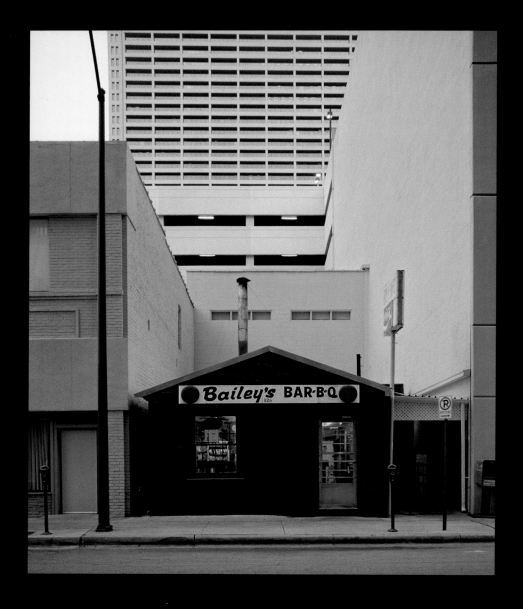

"I THINK BARBECUE, THE BAR-BECUE TRADITION, GOES BACK TO THE DAY OF THE COWBOYS. YOU KNOW, OUT ON THE TRAIL RIDES THEY'D MAKE THOSE OPEN PITS, AND THEY WERE COOKING WITH WOOD AND ROASTING THEIR MEAT OVER THE FIRE. WELL, THEY WERE BARBECUING. TODAY WE'RE STILL DOING IT. CRAVING IT. EVERYBODY'S INTO BARBECUE."

JOE CAPELLO, 61, PITMASTER 45 YEARS, CITY MARKET

MAMA & PAPA B'S BAR-B-QUE : *Waco*

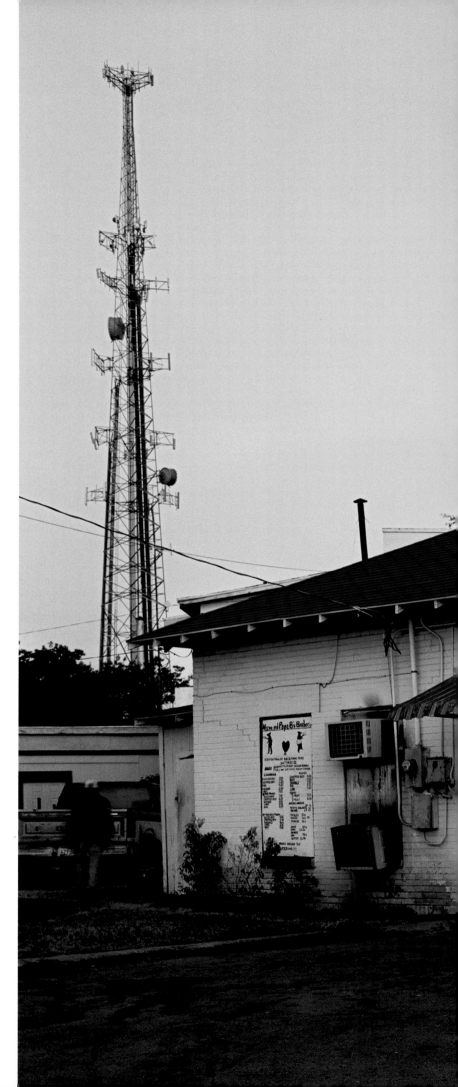

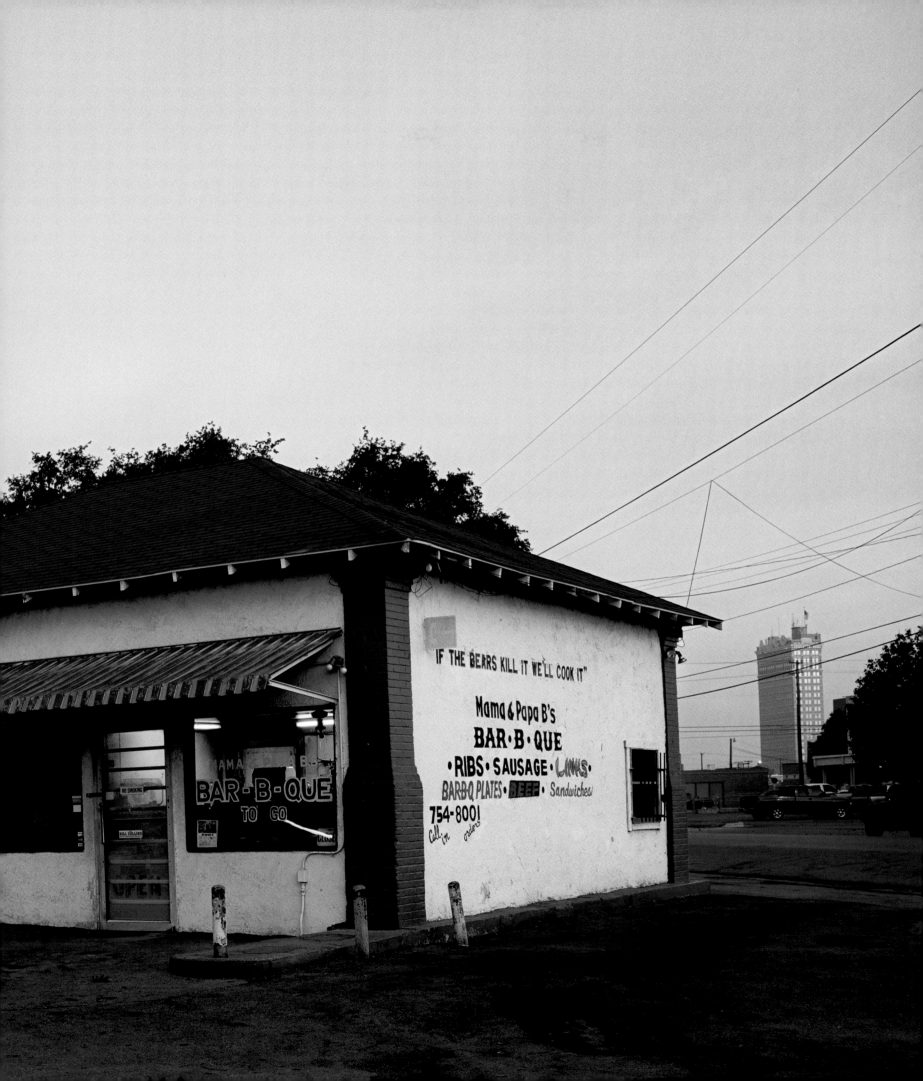

PRAUSE MEAT MARKET : *La Grange*

FRESH MEAT

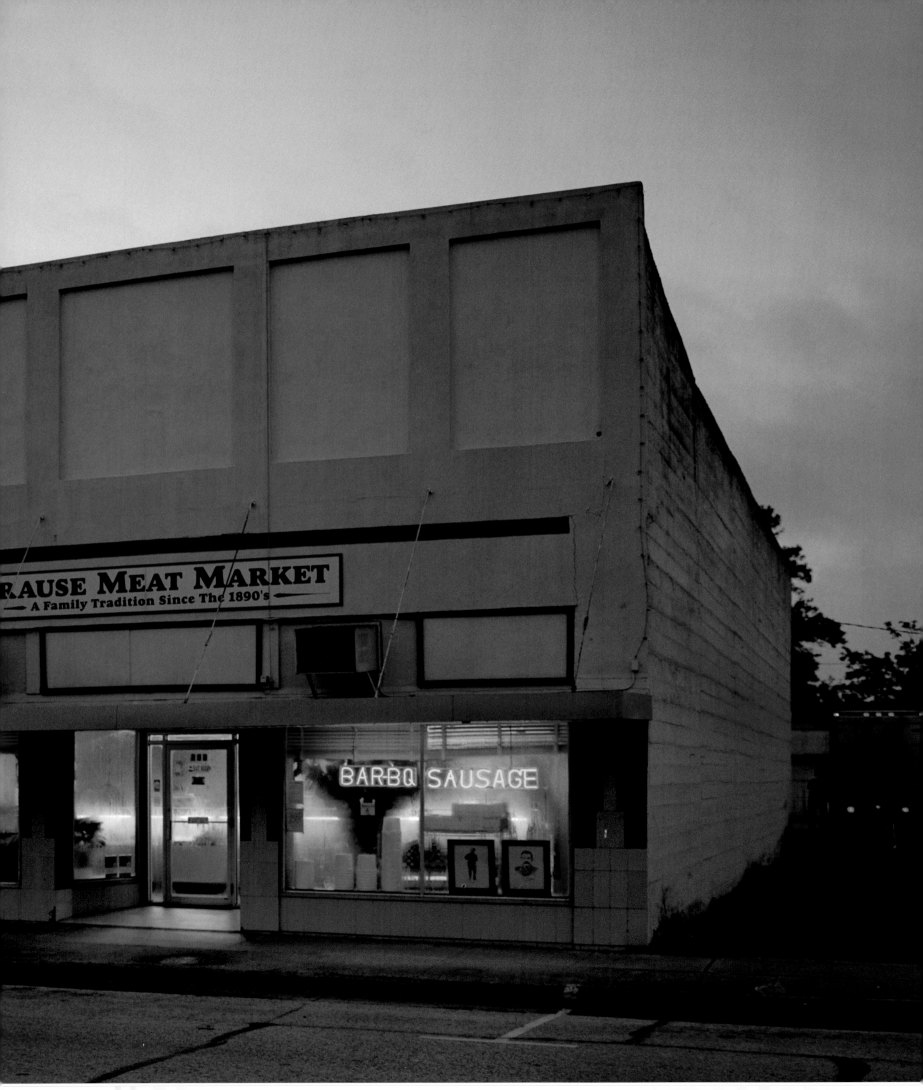

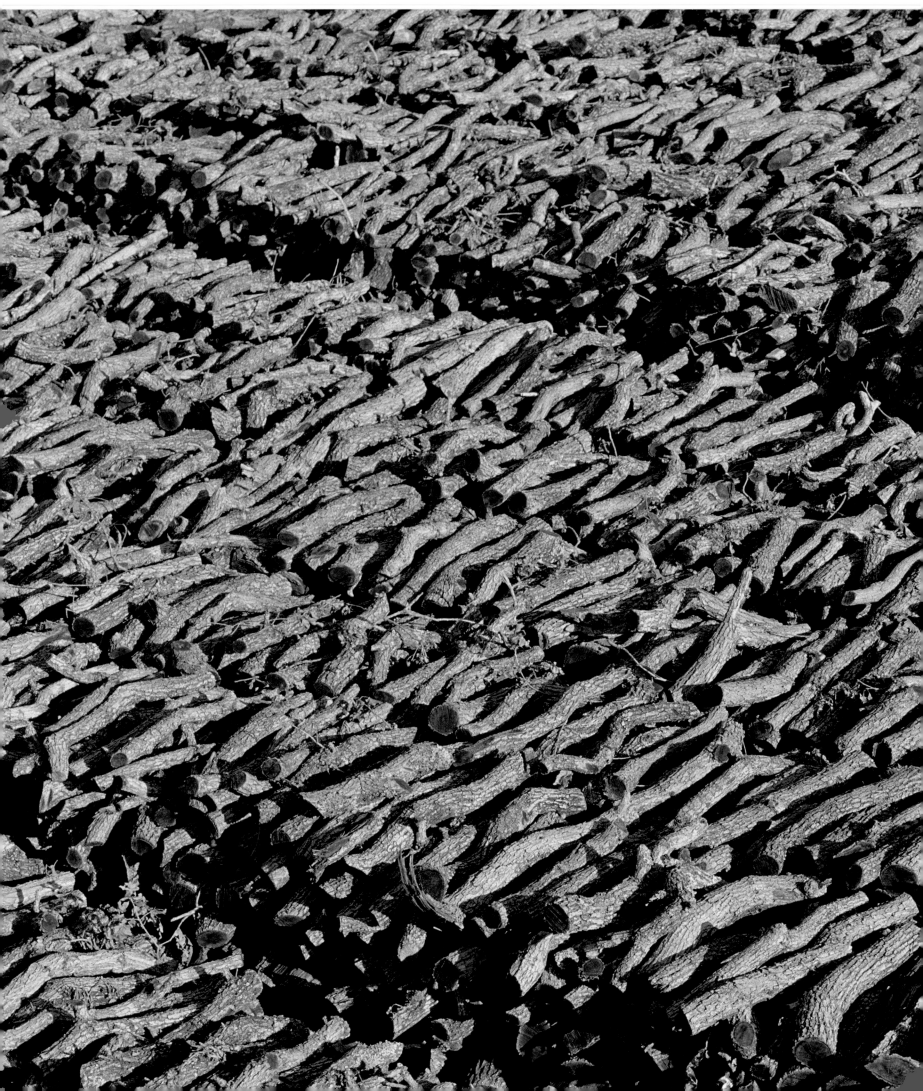

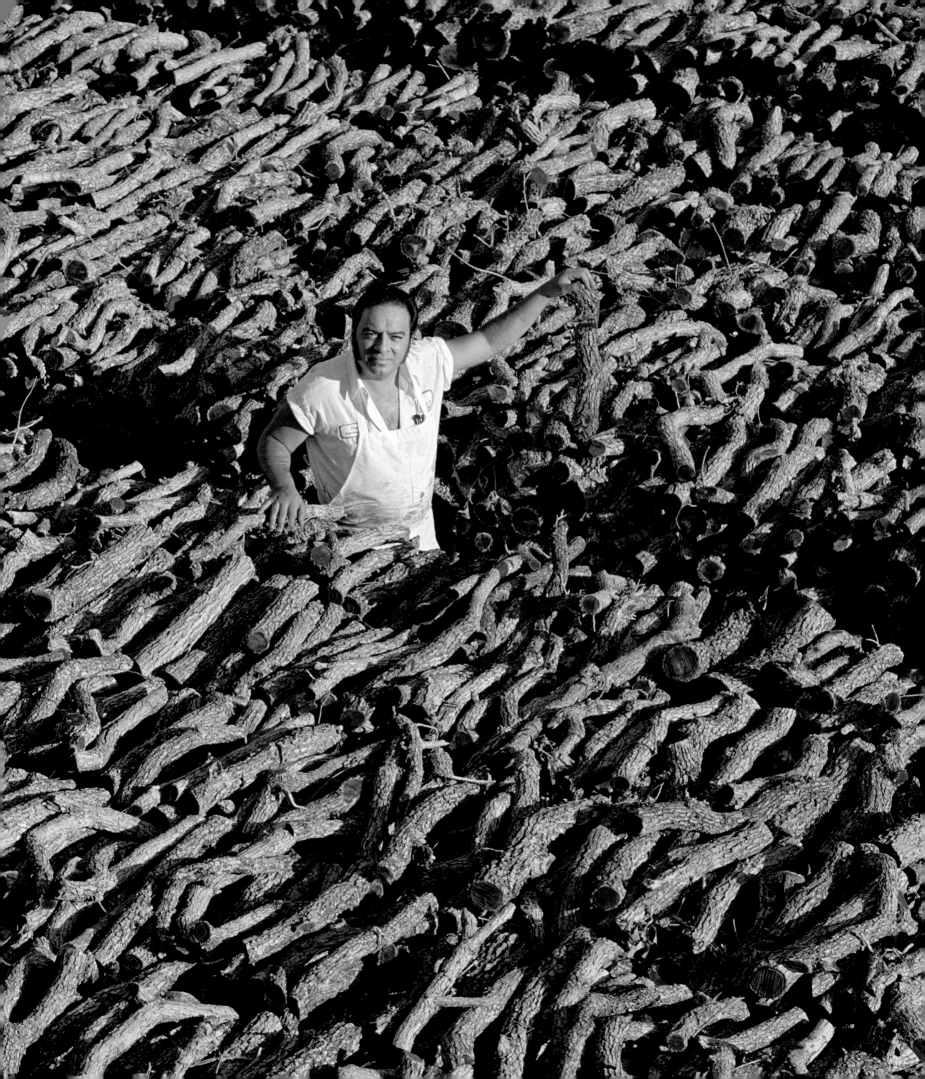

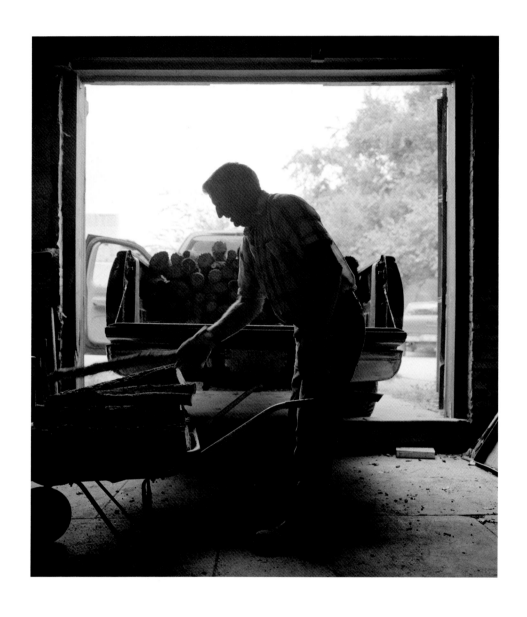

Wood man Tillman Reid **GONZALES FOOD MARKET** *Gonzales*

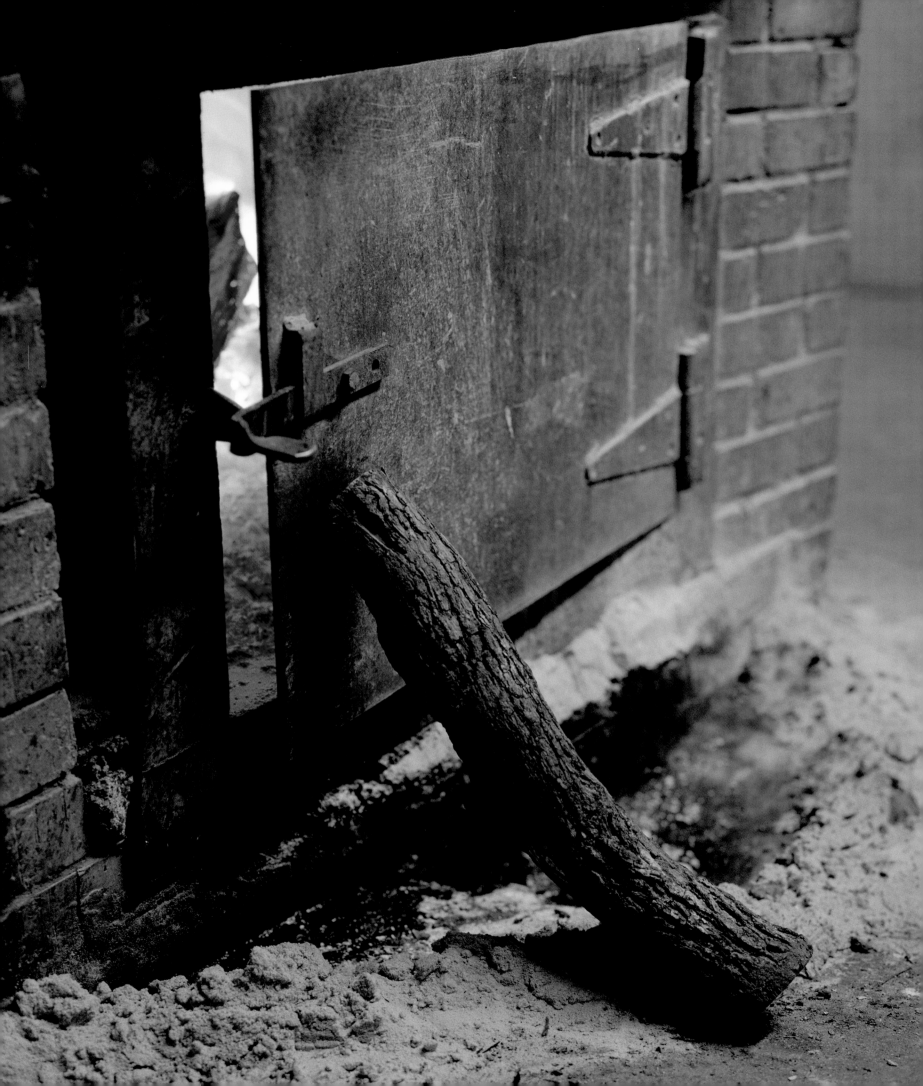

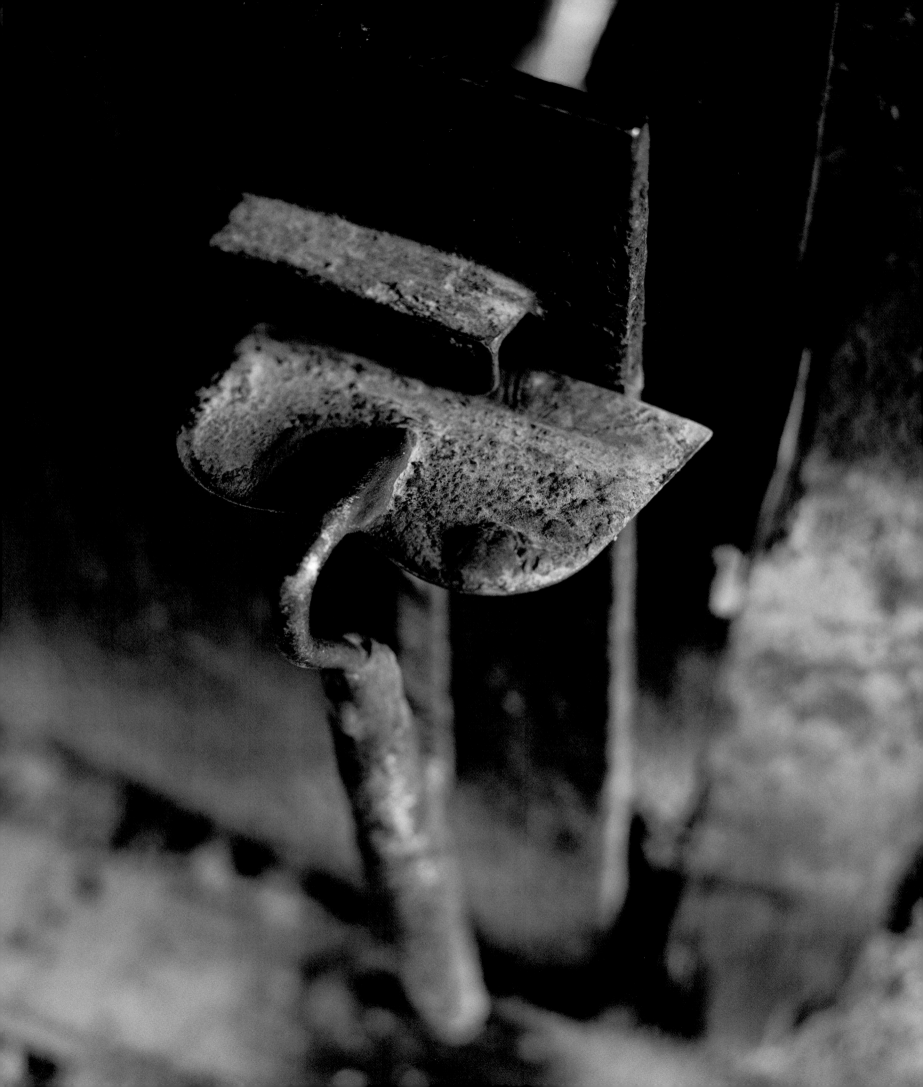

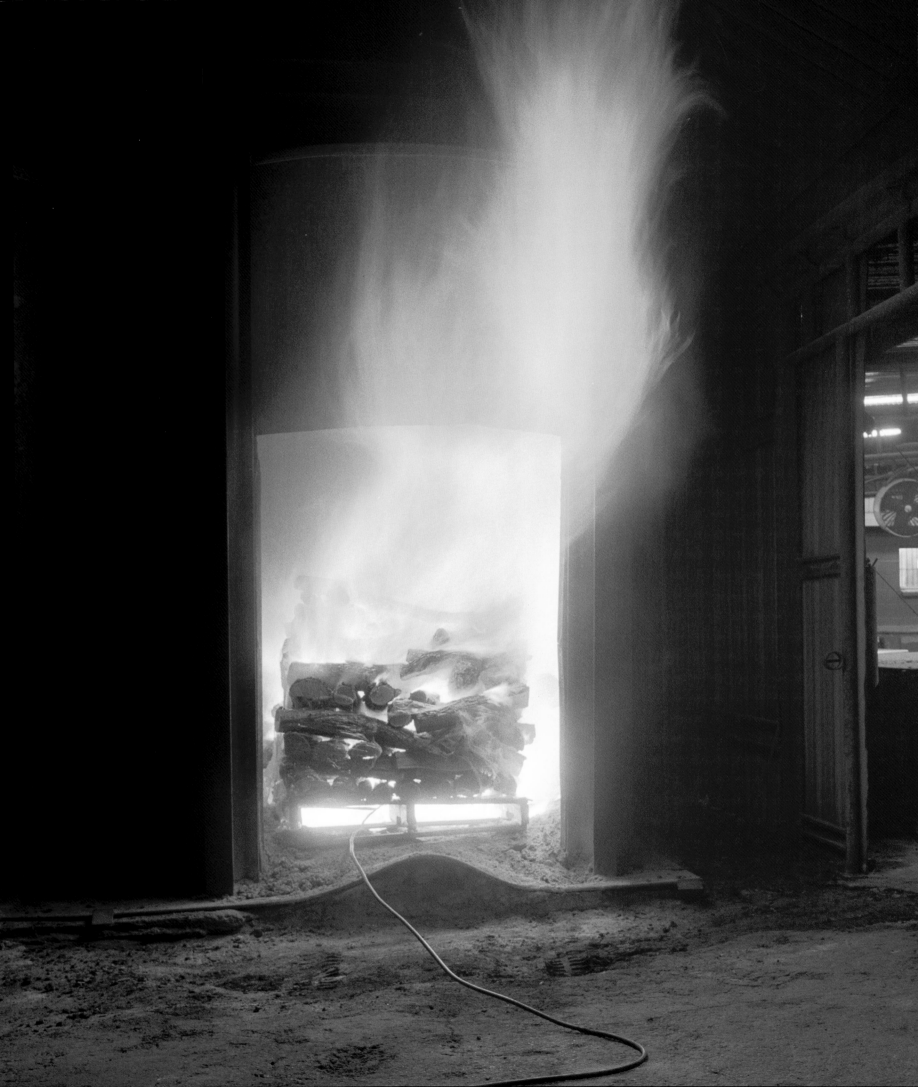

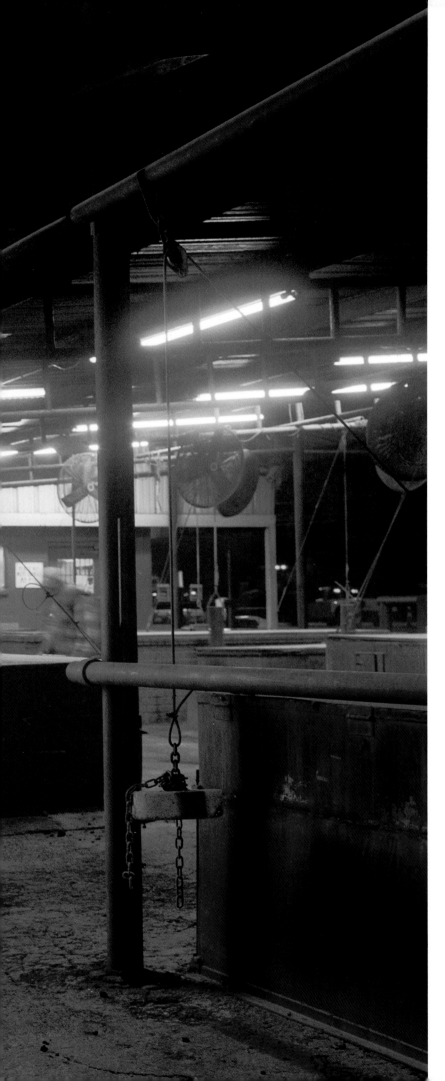

Mesquite blaze
COOPER'S OLD TIME PIT BAR-B-QUE : *Llano*

Danny Martinez (P. 66)
Firebox at dawn (P. 67)
COOPER'S PIT BAR-B-Q : *Mason* ▶

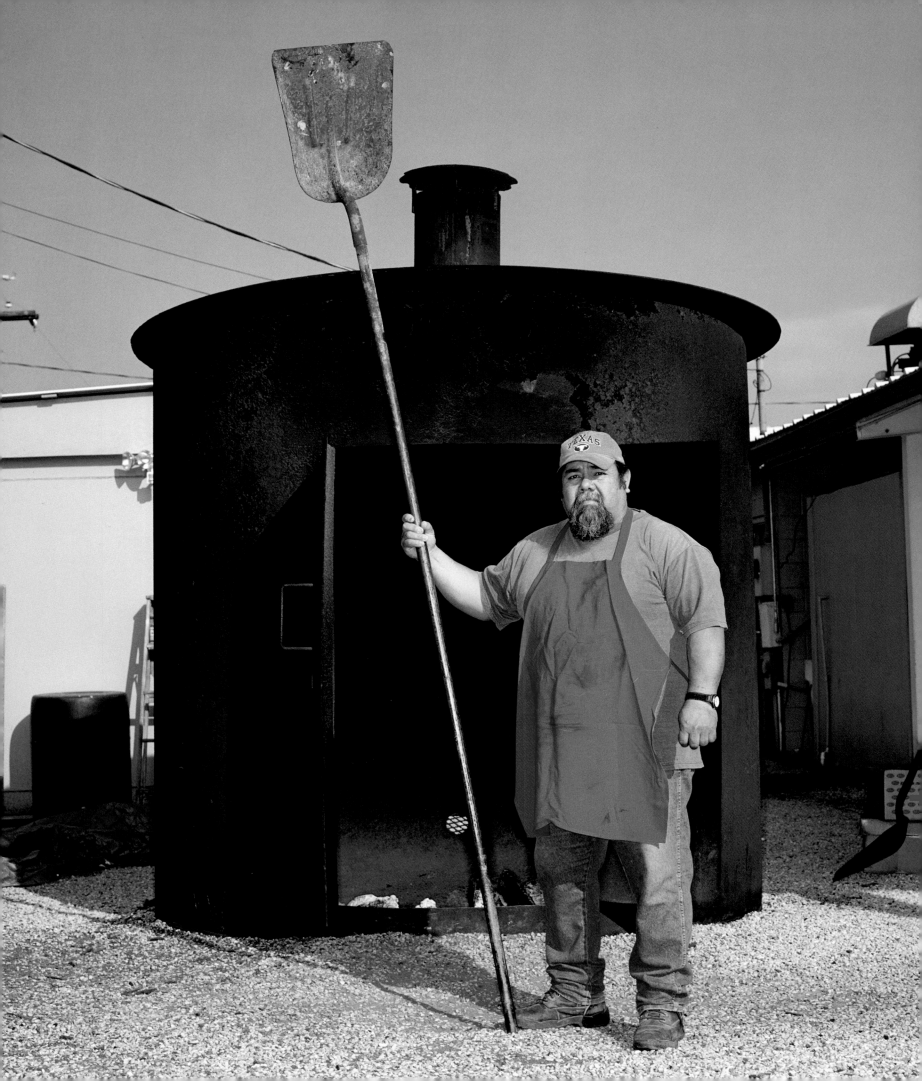

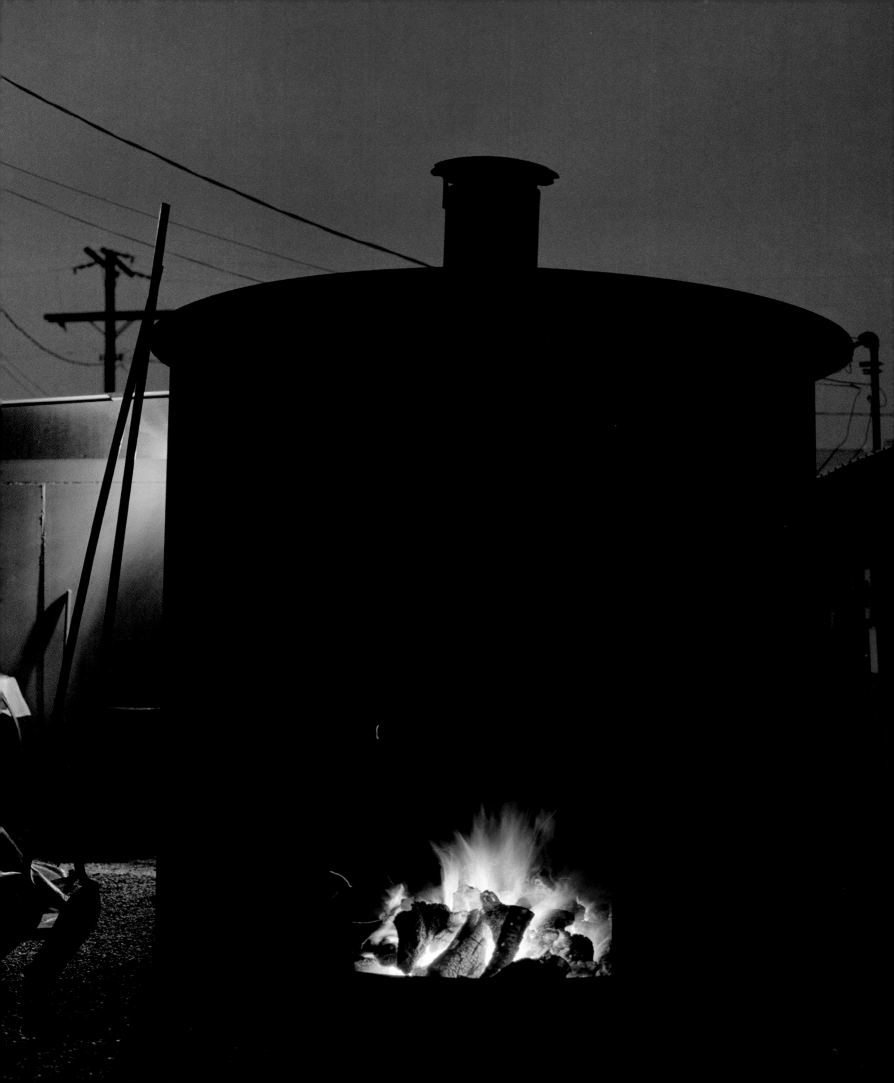

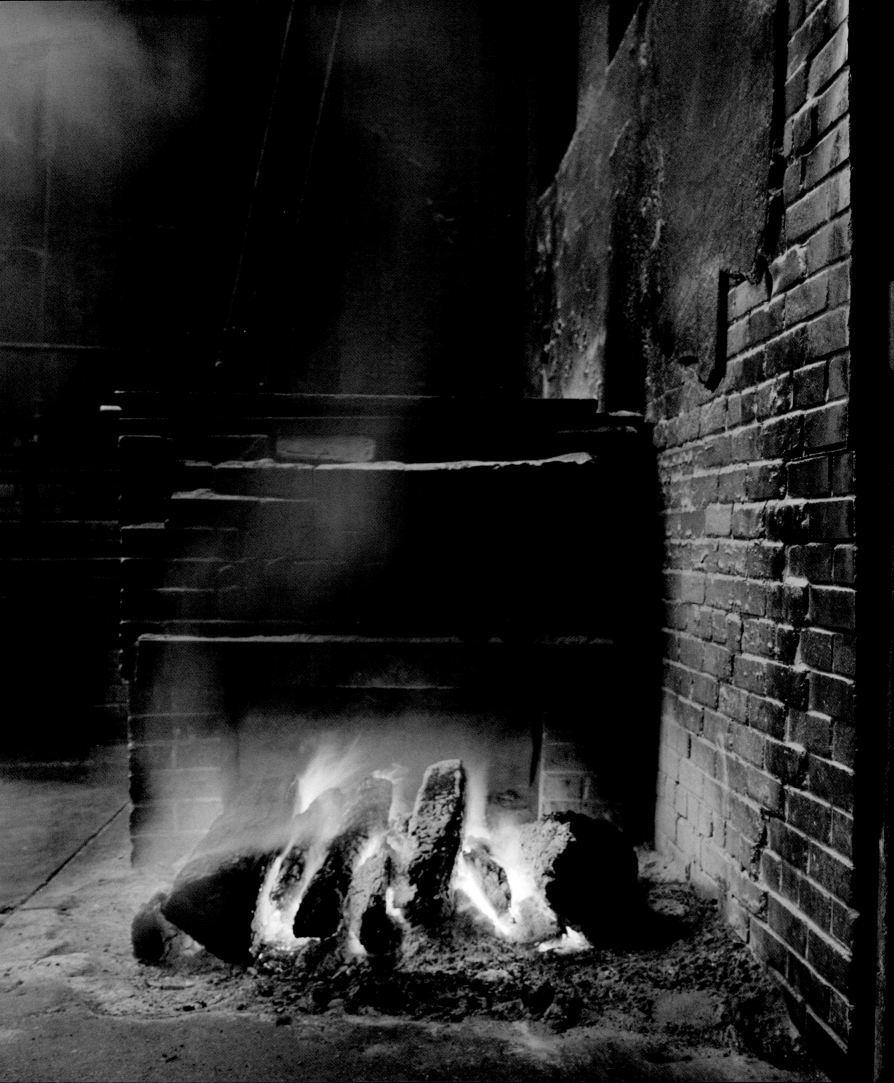

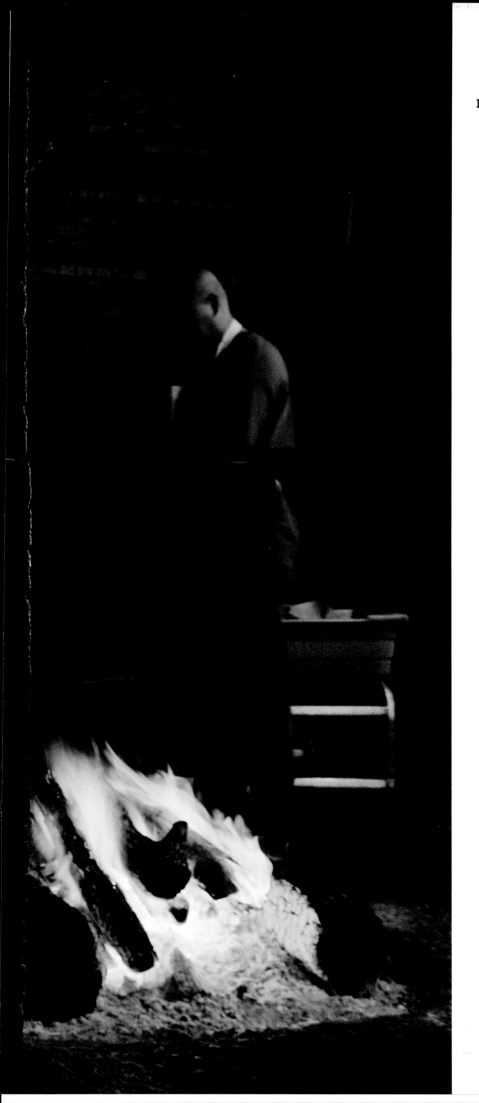

Brick pits : **SMITTY'S MARKET** : *Lockhart*

"I CAME BACK FROM THE SERVICE IN '45. WORKED AT SOUTHSIDE MARKET IN '46 AND '47, AND THEN IN '48 I COME OVER HERE. I BUILT TWO BIG BRICK PITS, COOK ABOUT 400 POUNDS OF MEAT ON 'EM—ON EACH ONE OF 'EM. MAINLY BRISKET AND PORK RIBS AND SAUSAGE—PEOPLE SURE DO LIKE THOSE THREE. CHICKEN'S KINDA SLOW."

VENCIL MARES, 84, PITMASTER 60 YEARS, TAYLOR CAFE

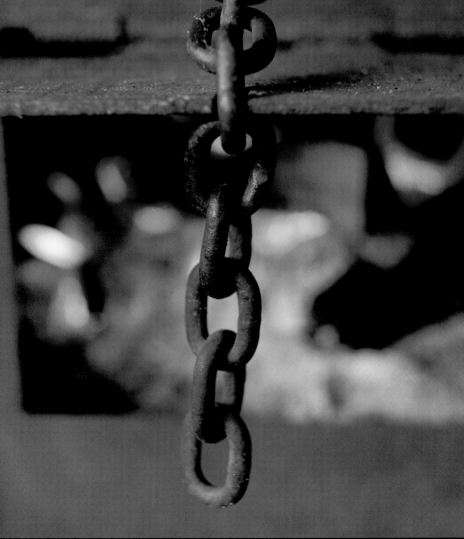

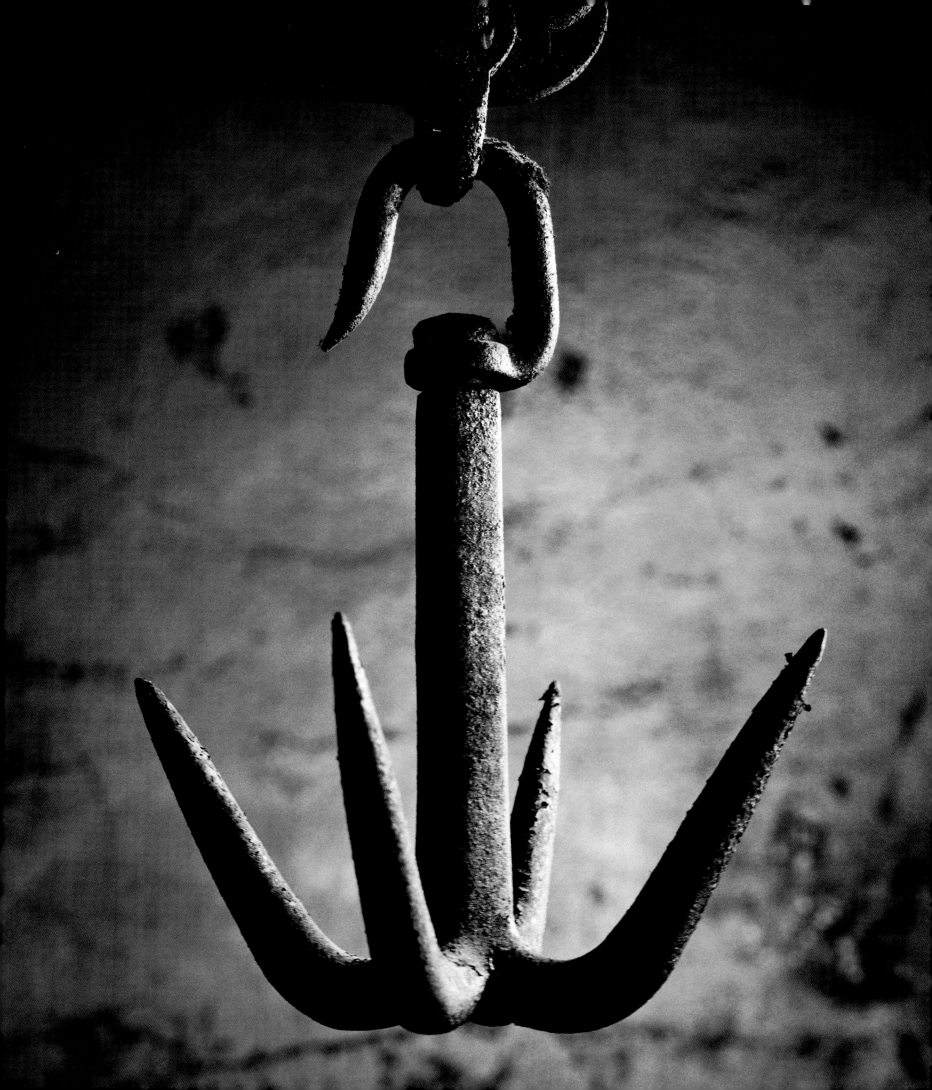

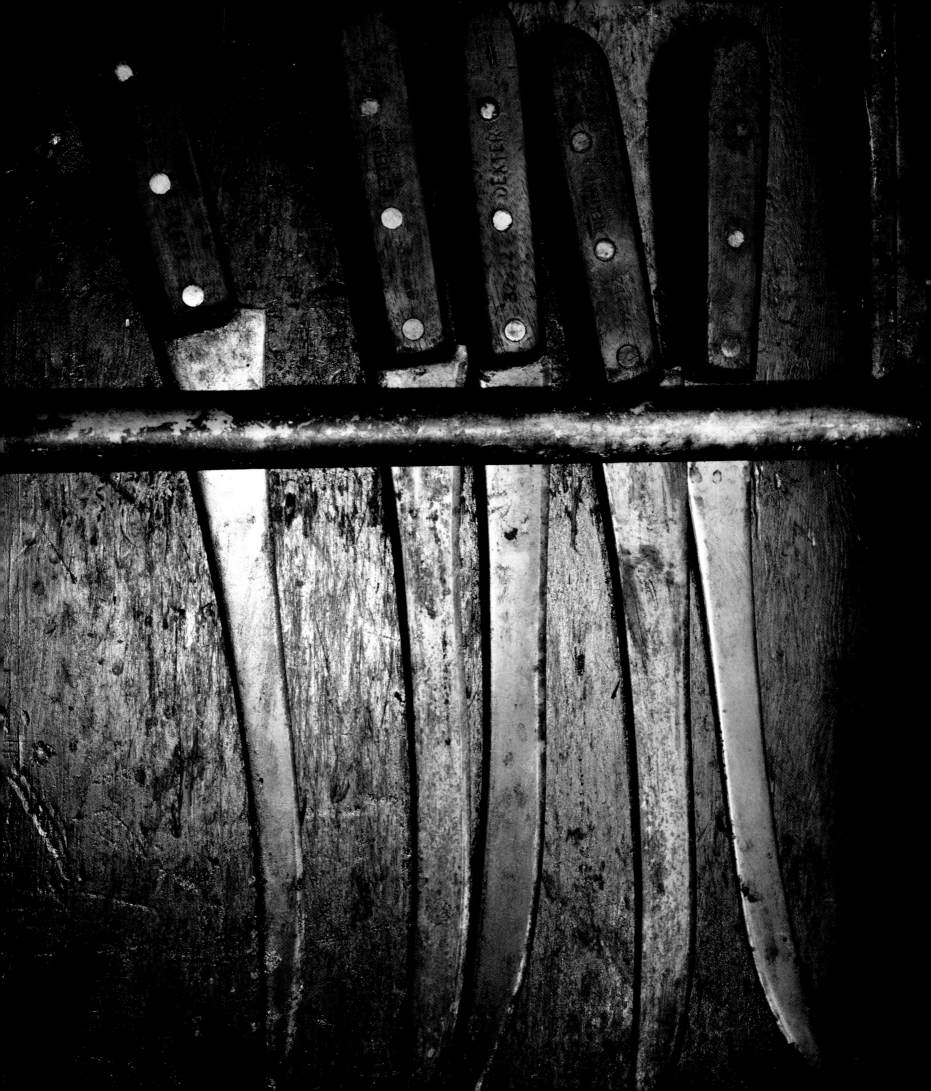

Knives : **KREUZ MARKET** (ORIGINAL LOCATION) : *Lockhart*

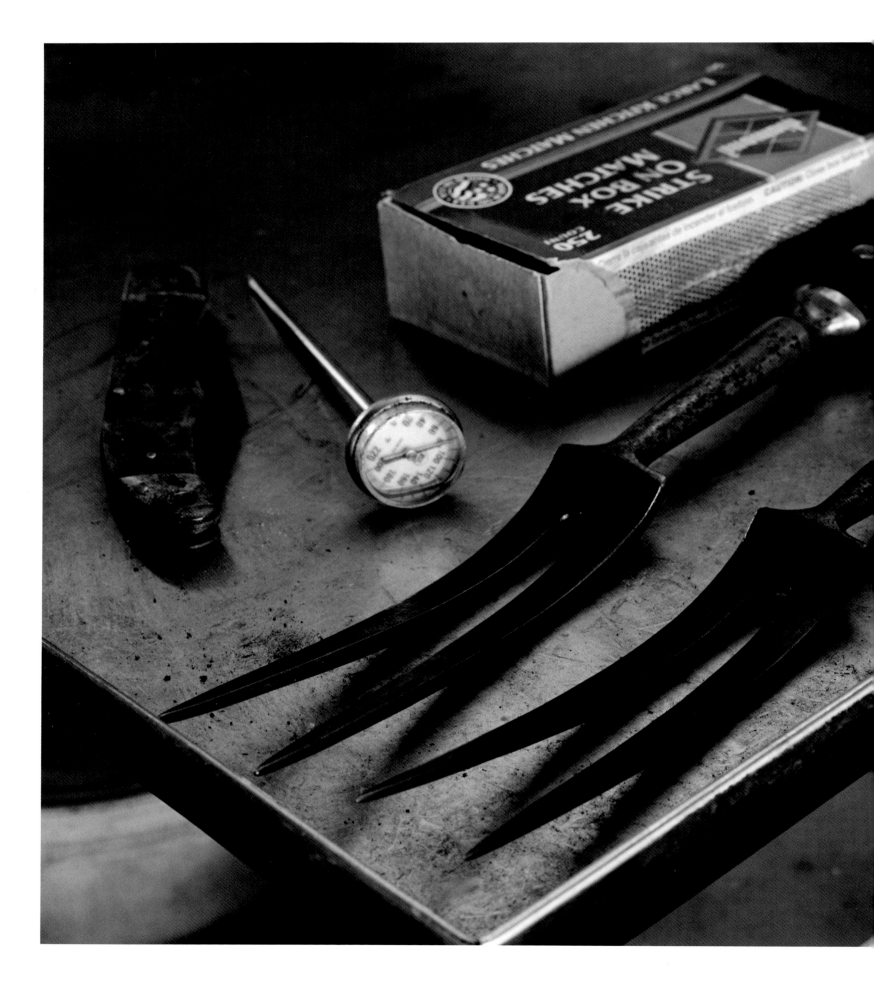

Forks : **DOZIER'S GROCERY, INC.** : *Fulshear*

Rub and ribs **: GONZALES FOOD MARKET :** *Gonzales*

Pork ribs (P. 84)

Peppered chops (P. 85)

COOPER'S OLD TIME PIT BAR-B-QUE : *Llano* ▶

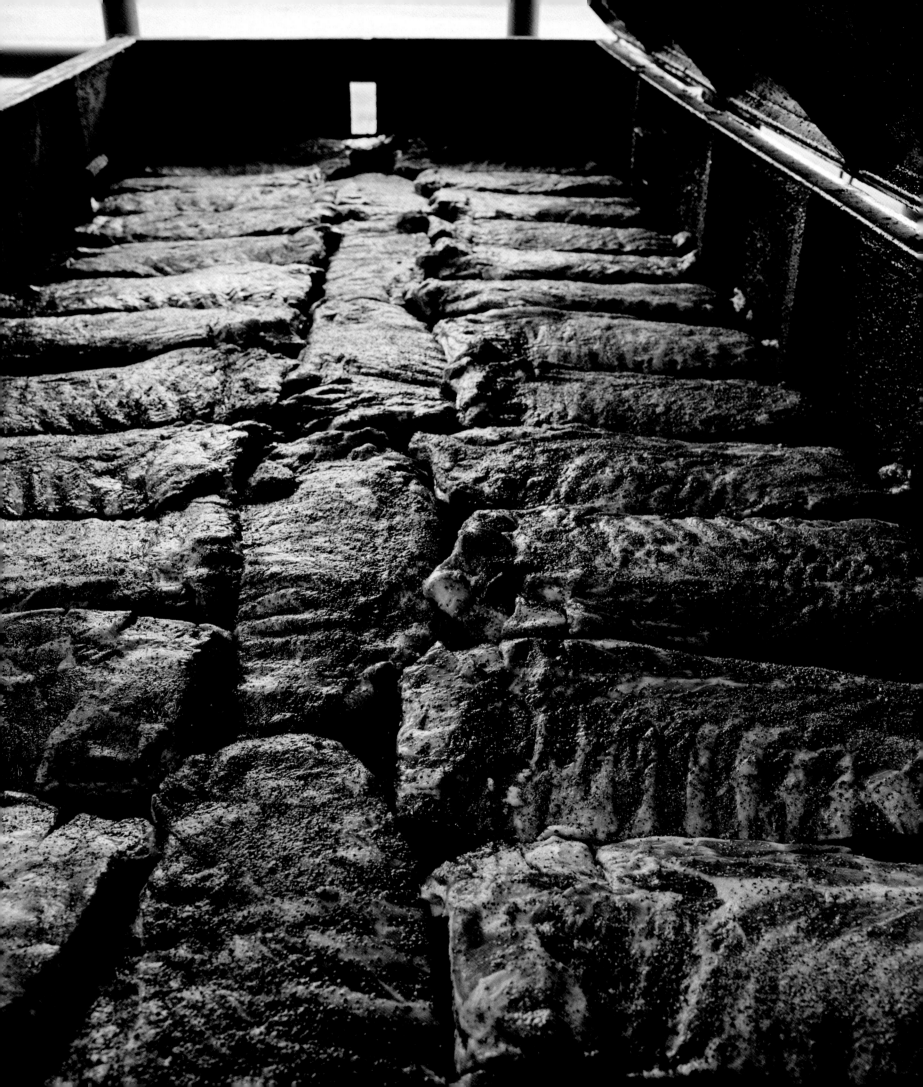

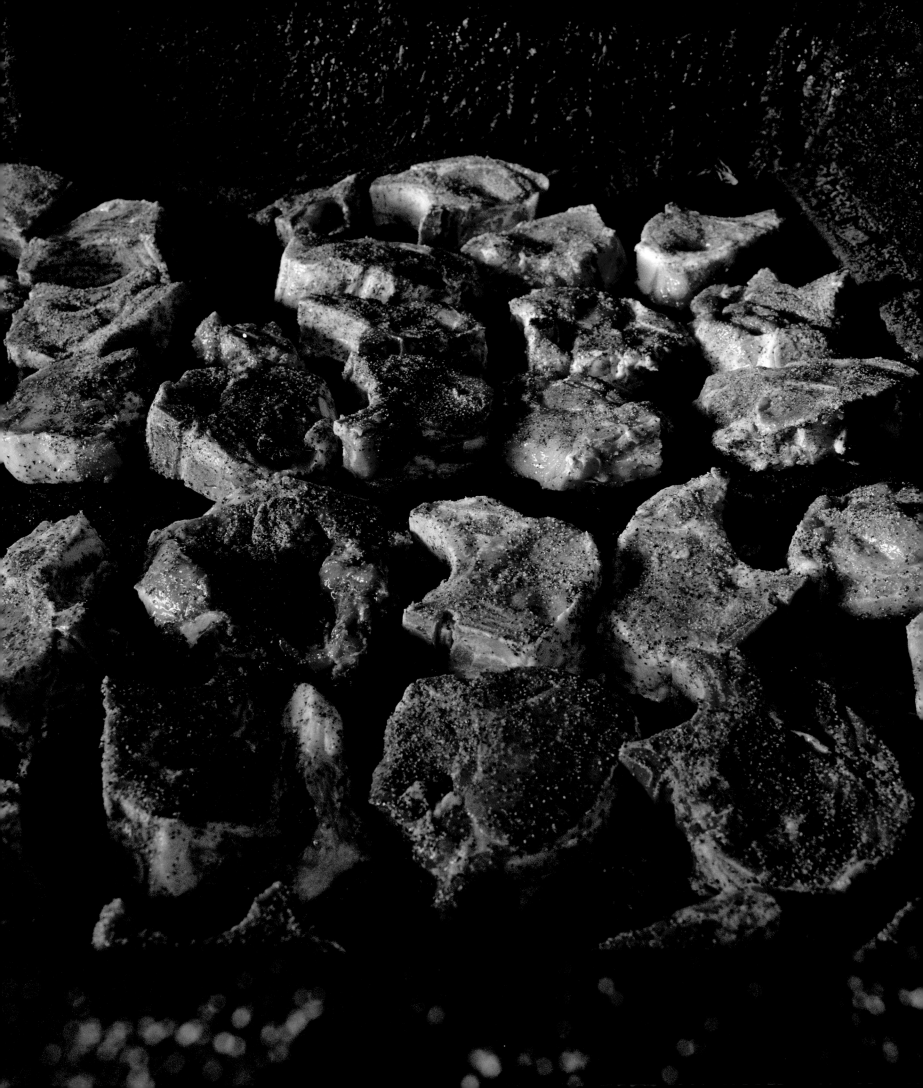

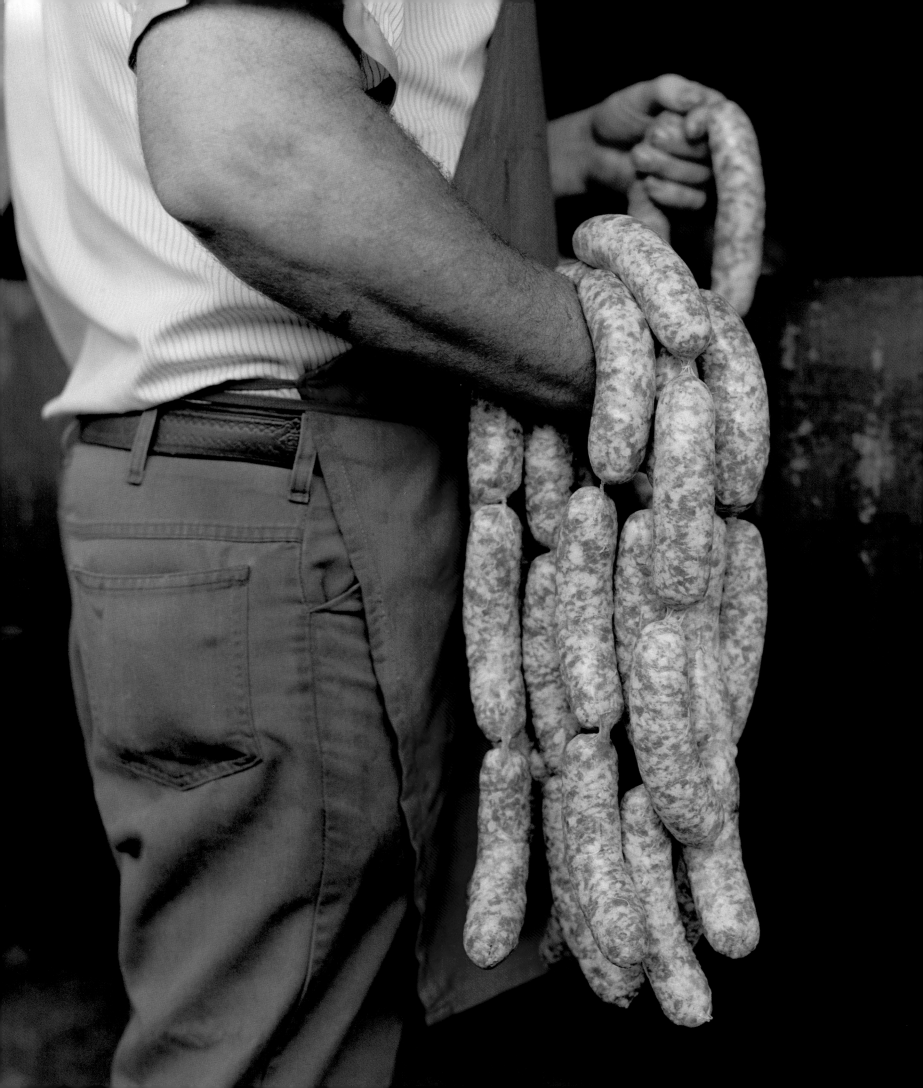

◄ Fresh links **:** **ZIMMERHANZEL'S BAR-B-QUE :** *Smithville*

Making sausage **:** **GONZALES FOOD MARKET :** *Gonzales*

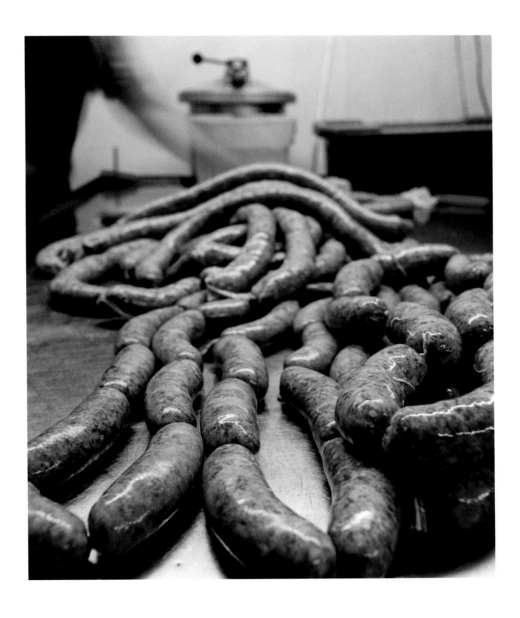

Hanging sausage **: CITY MARKET :** *Luling* ►

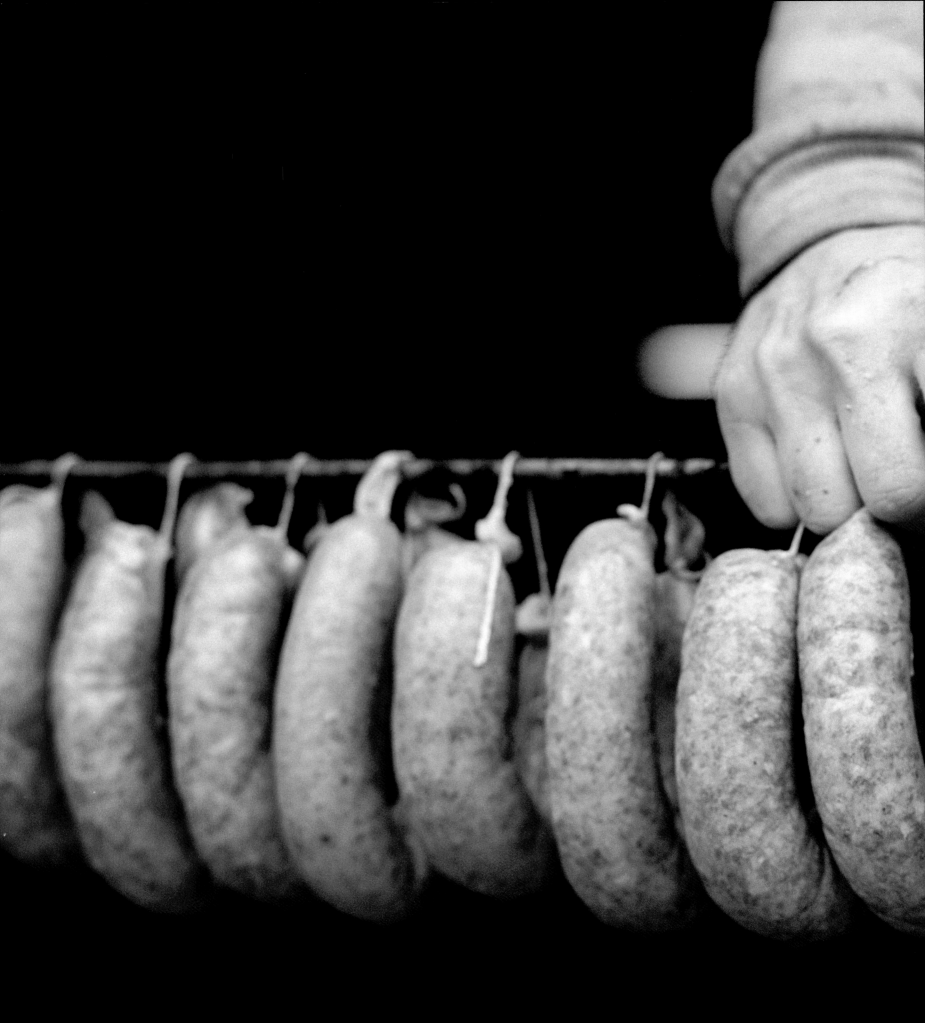

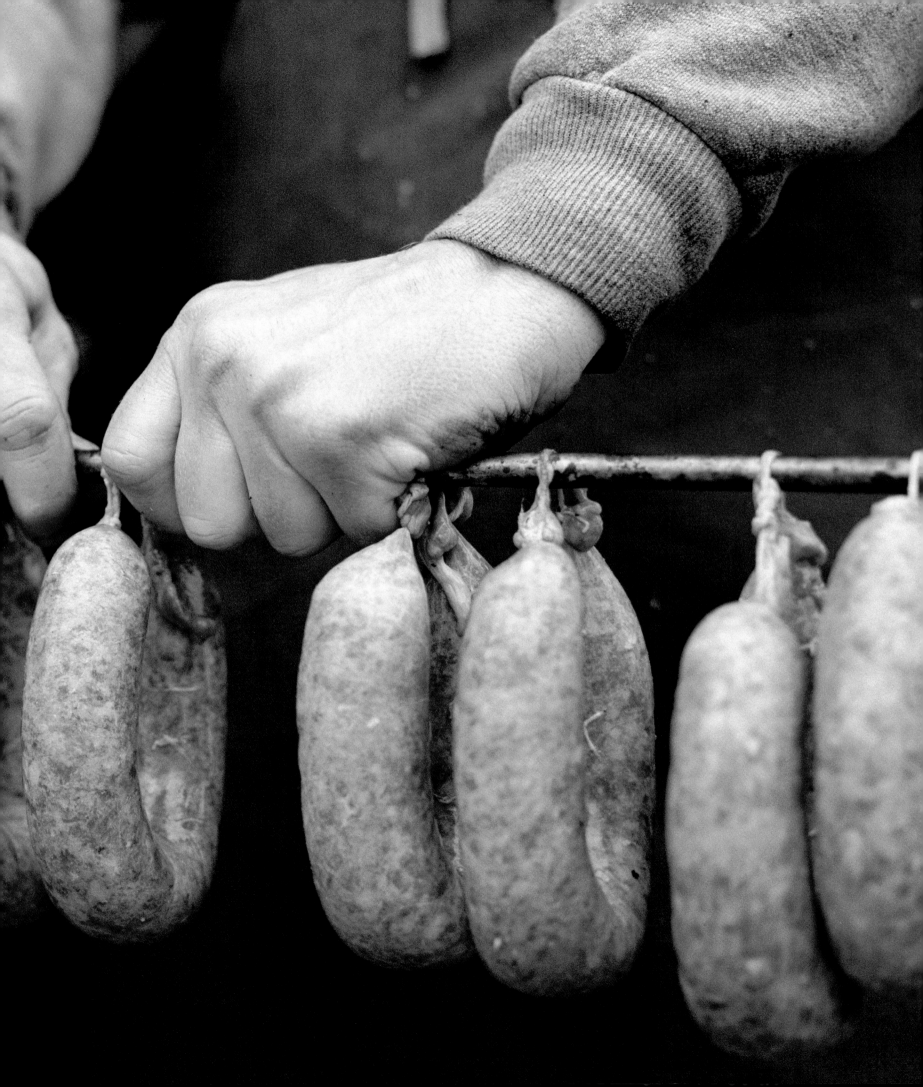

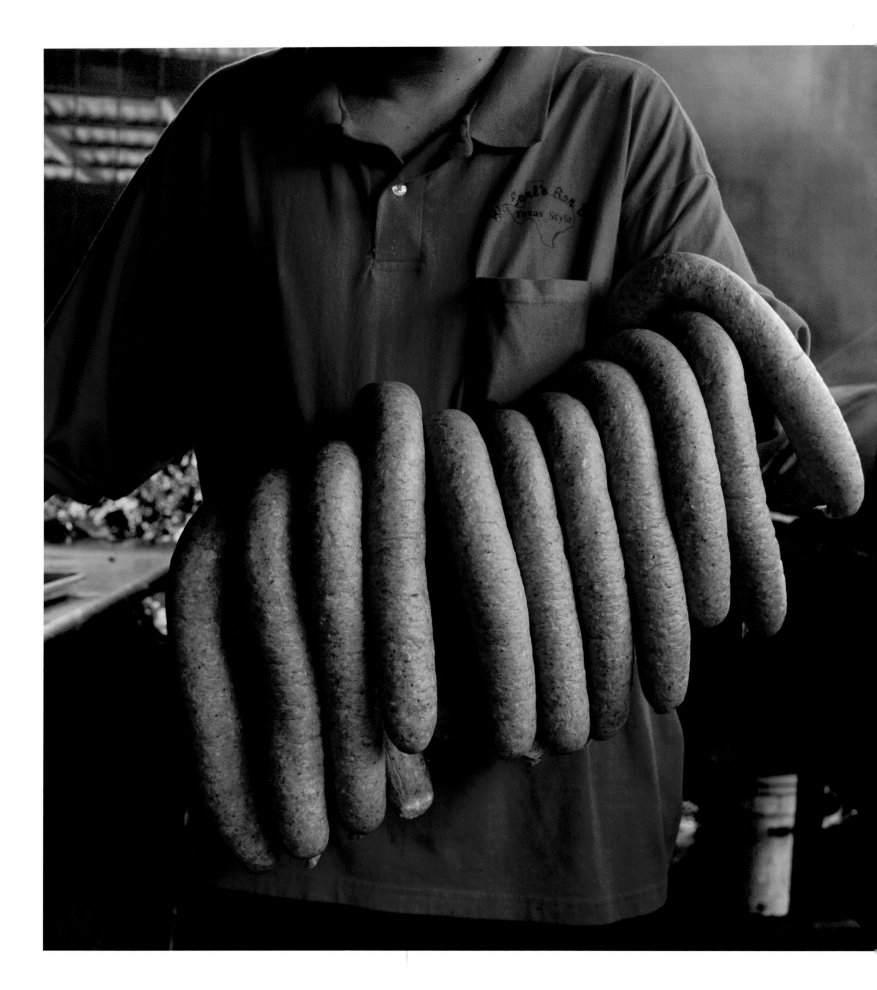

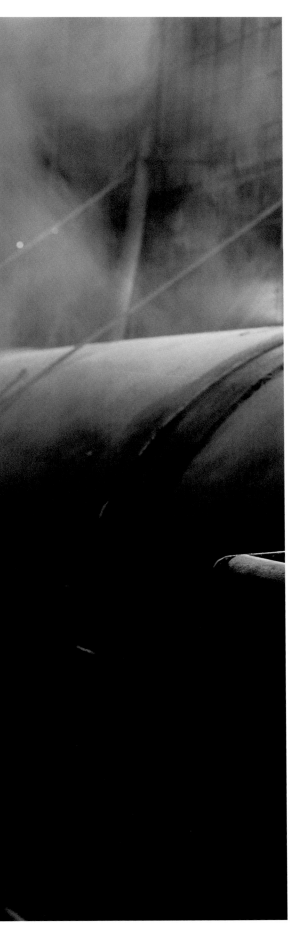

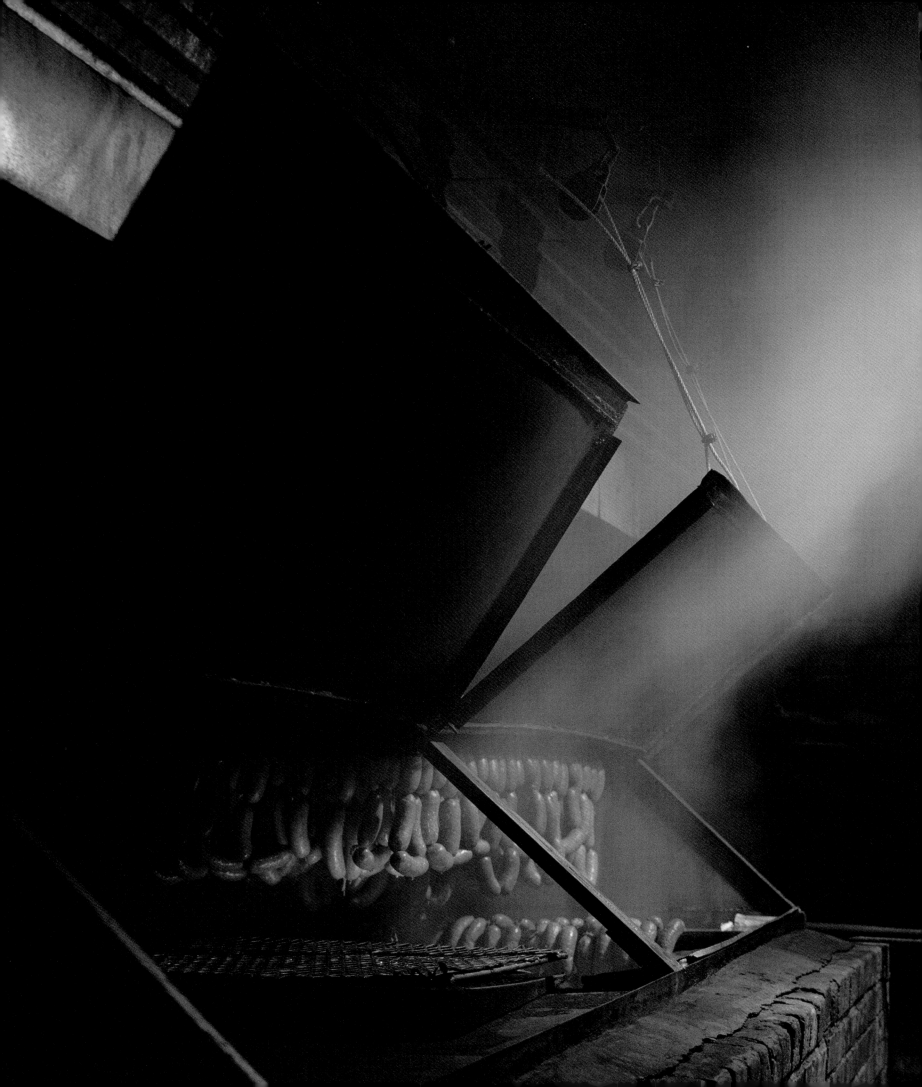

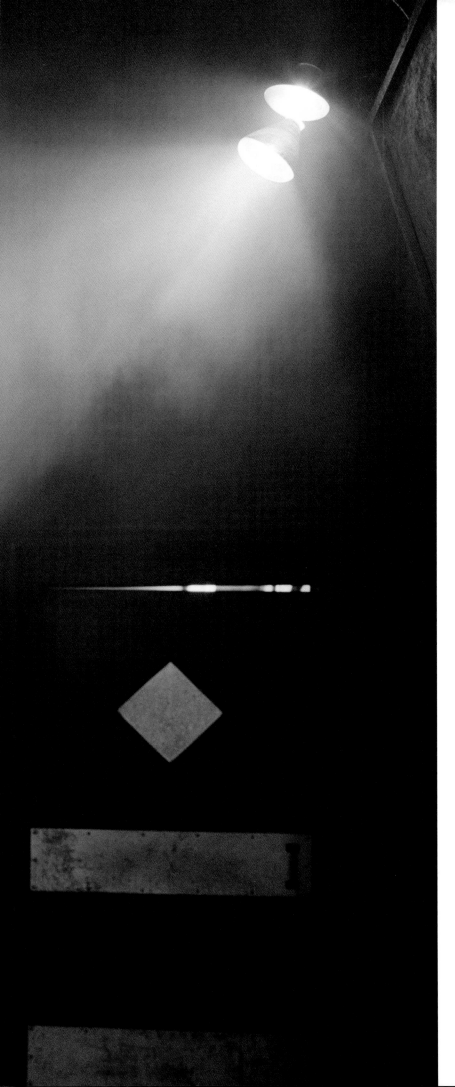

Smoking sausage

GONZALES FOOD MARKET : *Gonzales*

"YOU JUST CAN'T THROW MEAT IN AN OVEN AND COME BACK 24 HOURS LATER. YOU GOTTA SWEAT AND INHALE A LOT OF SMOKE. YOU GOTTA COOK RIGHT OVER THE COALS WHERE THE MEAT CAN DRIP DOWN—THEN THE FLAVOR CAN COME BACK UP THROUGH IT. YOU CAN'T BE LAZY IF YOU WANT REAL TEXAS BARBECUE, YOU GOTTA DO THE WORK."

STEVE KAPCHINSKIE, 52, PITMASTER 29 YEARS, MARTIN'S PLACE

Pit thermometer : **LAZY H SMOKEHOUSE** : *Kirbyville*

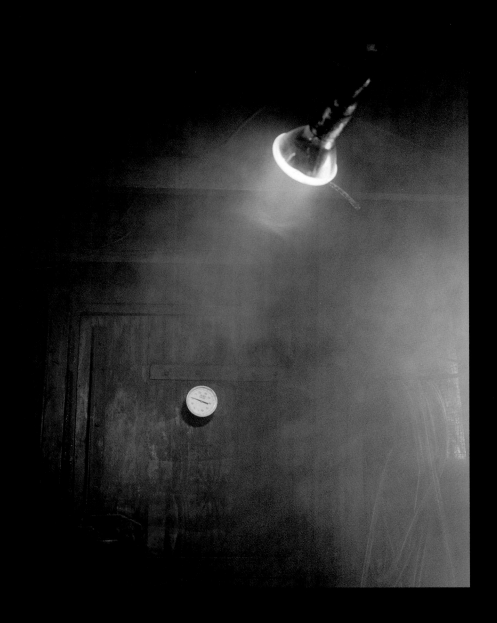

Loaded pit : **EURESTE GROCERY** : *Waelder*

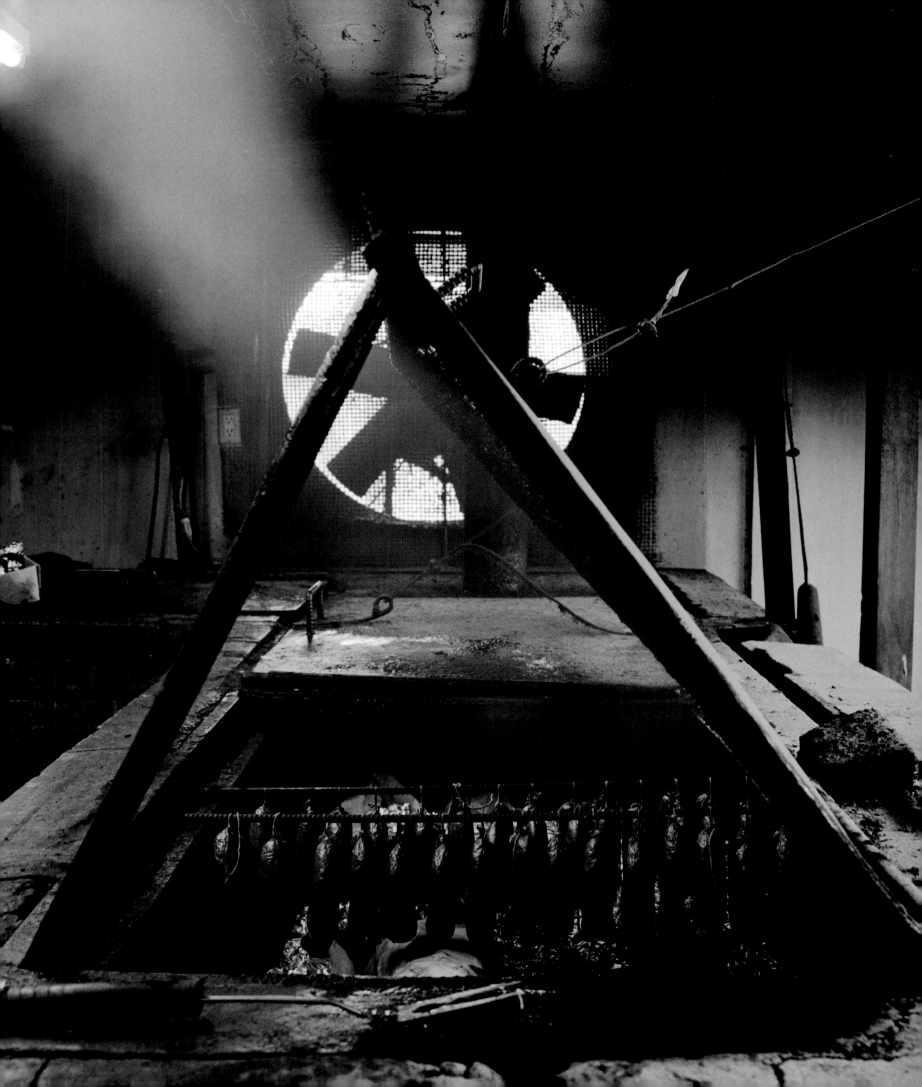

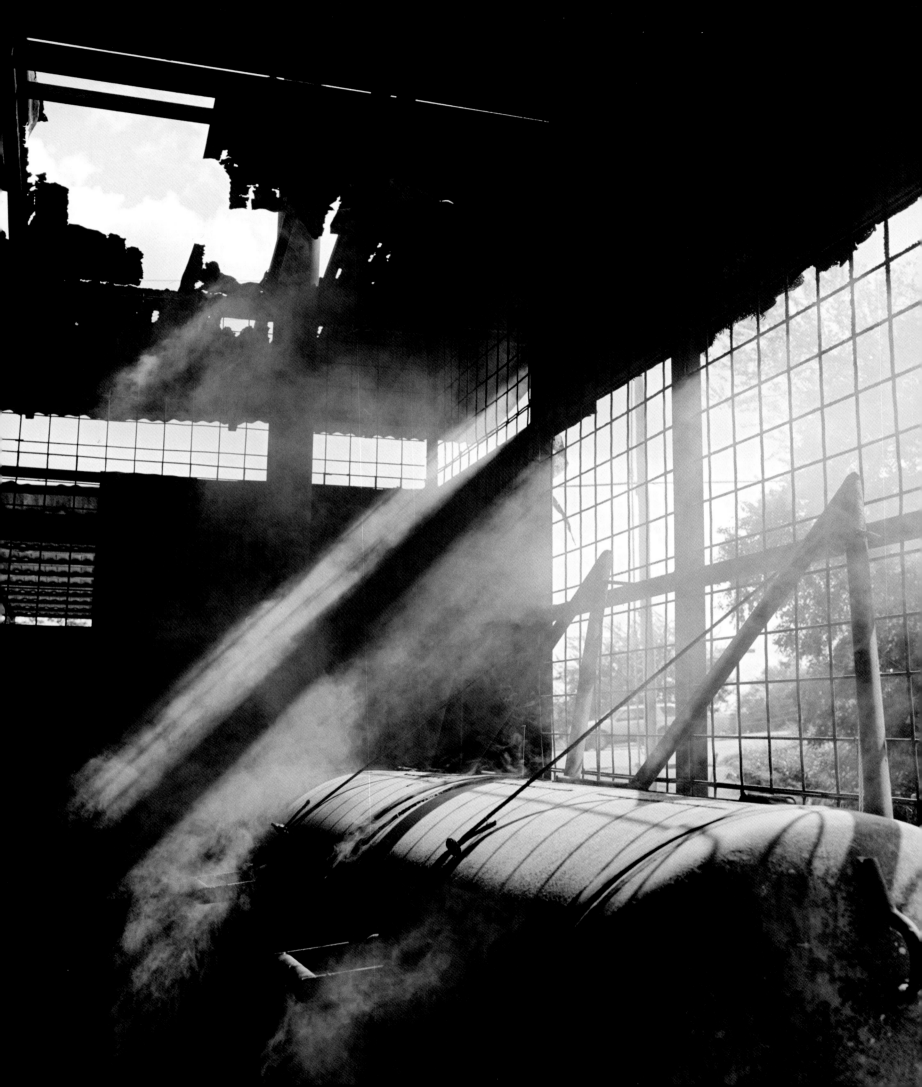

Smoker : **BIG EARL'S TEXAS STYLE BAR-B-QUE** : *Kerrville*

Smokestack : **MACK'S SPLIT RAIL BAR-B-Q** : *Mineola*

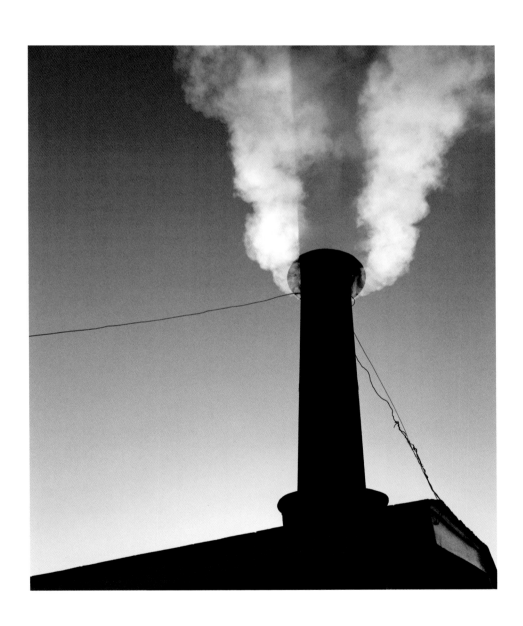

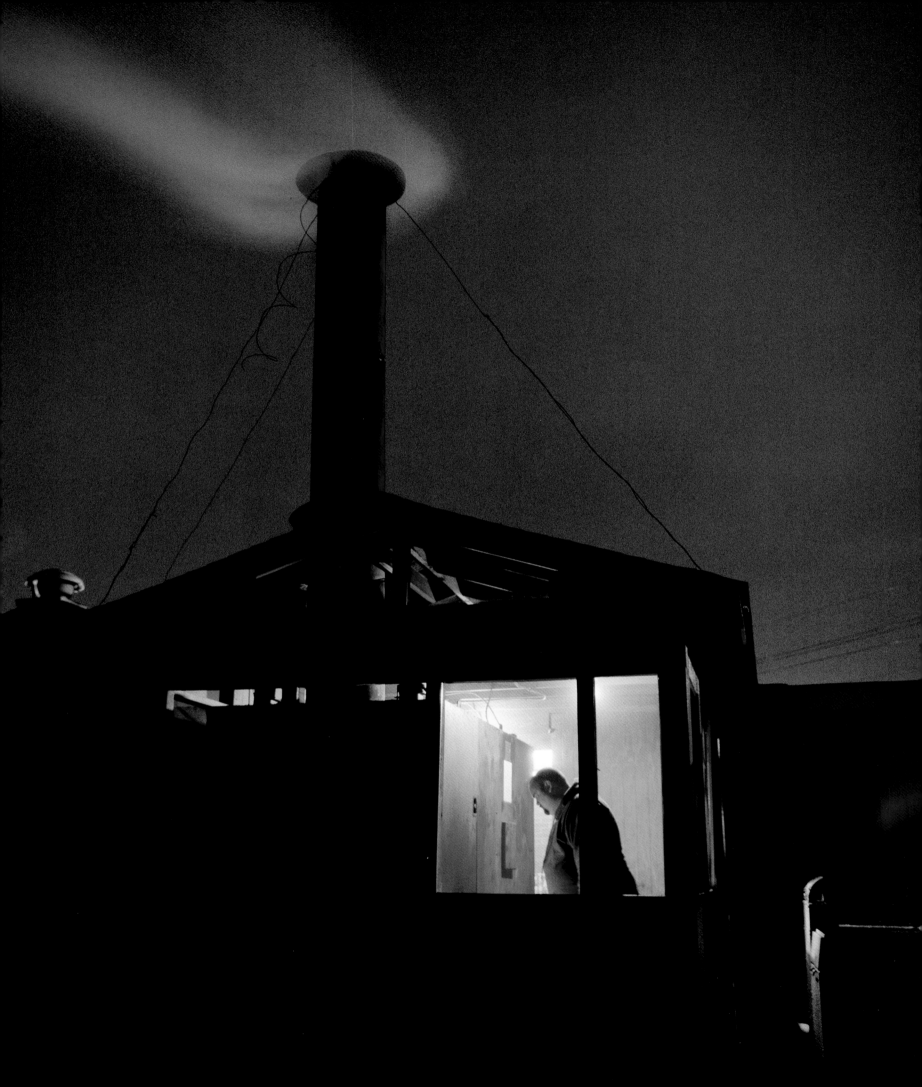

Lee West : **MACK'S SPLIT RAIL BAR-B-Q** : *Mineola*

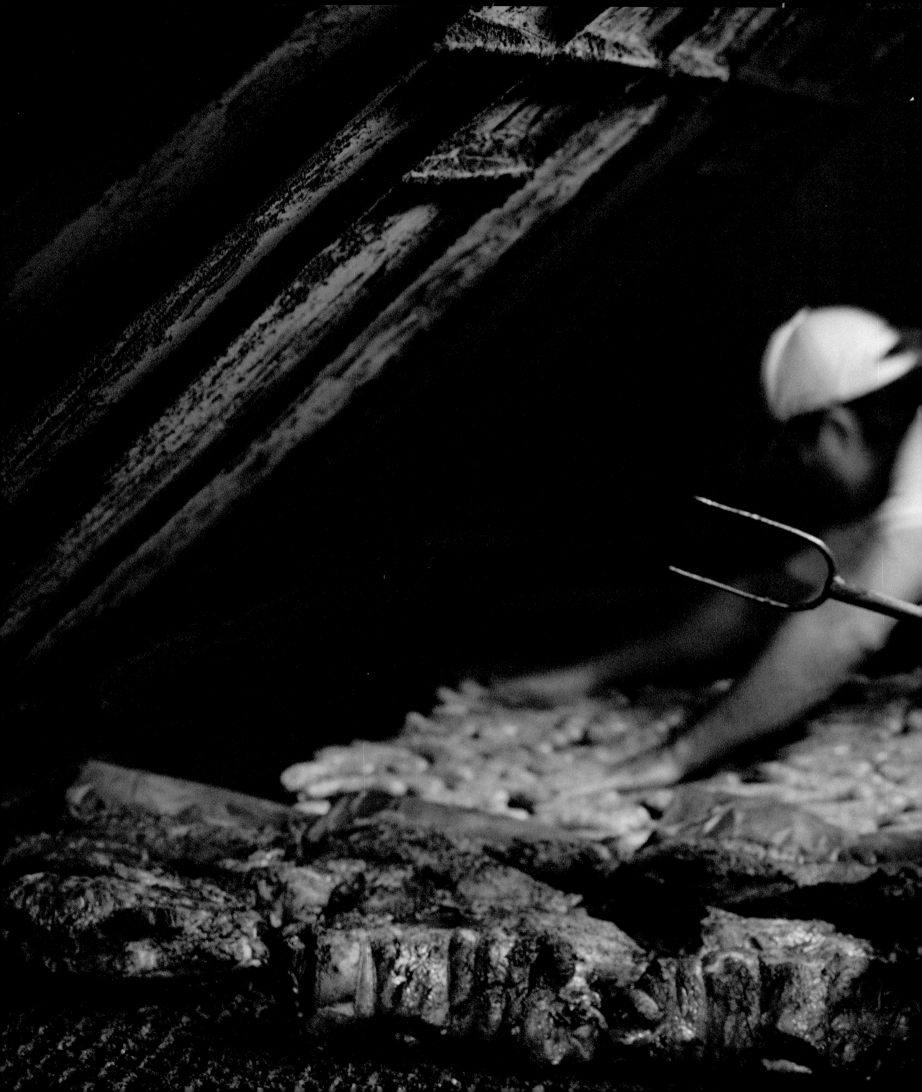

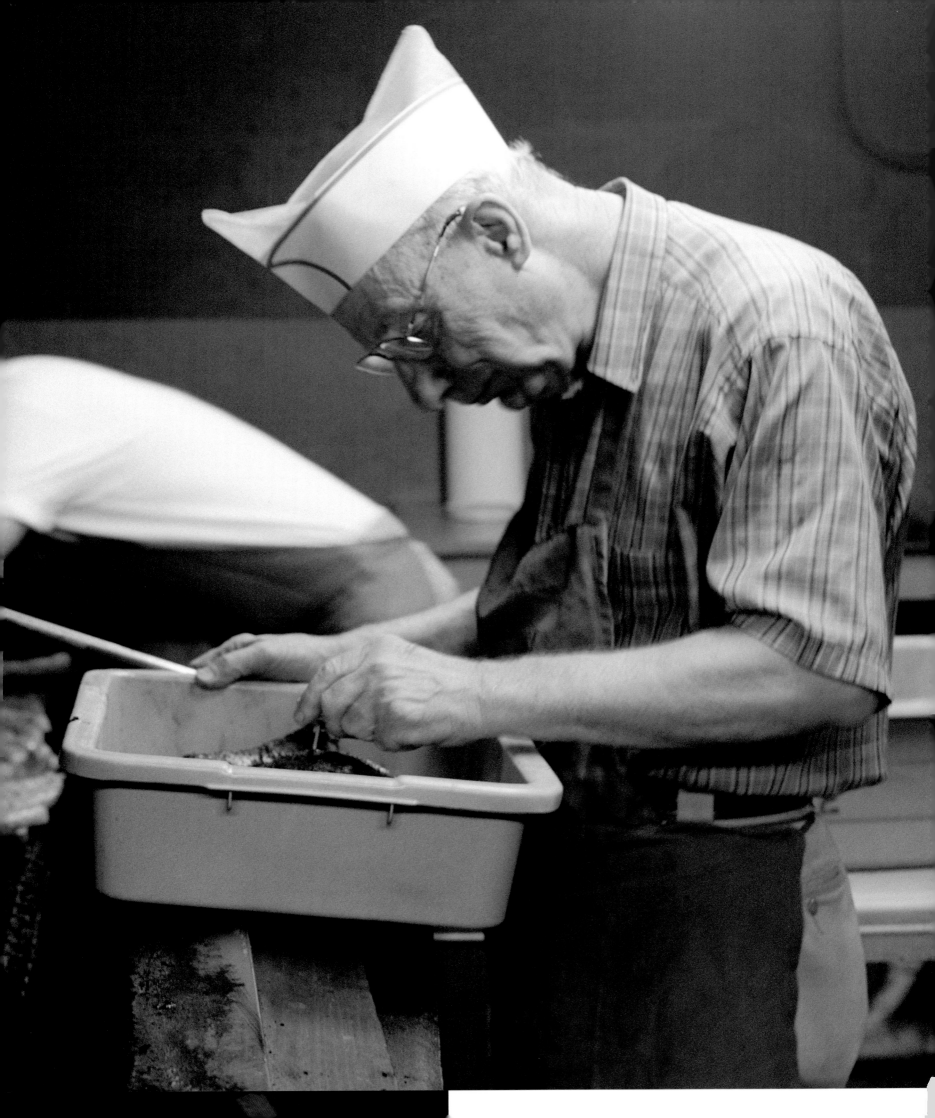

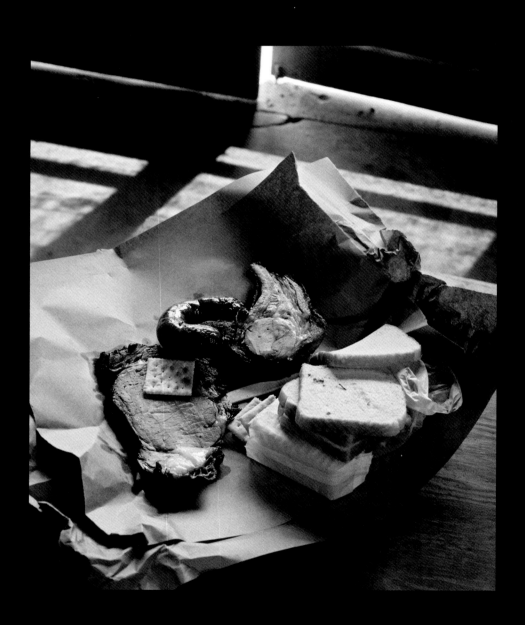

"I'M NOT GONNA SAY THAT OUR BARBECUE IS BETTER THAN ANYONE ELSE'S. I MEAN, I HOPE IT IS. BUT YOU CAN'T PLEASE EVERY-BODY. SOME PEOPLE GO FOR WHATEVER IS CHEAP, OR MAYBE THEY DON'T CARE WHAT THEY'RE GETTING IF THEY'RE HUNGRY. BUT REAL BARBECUE PEOPLE KNOW THIS IS THE GOOD STUFF."

ROY PEREZ, 45, PITMASTER 21 YEARS, KREUZ MARKET

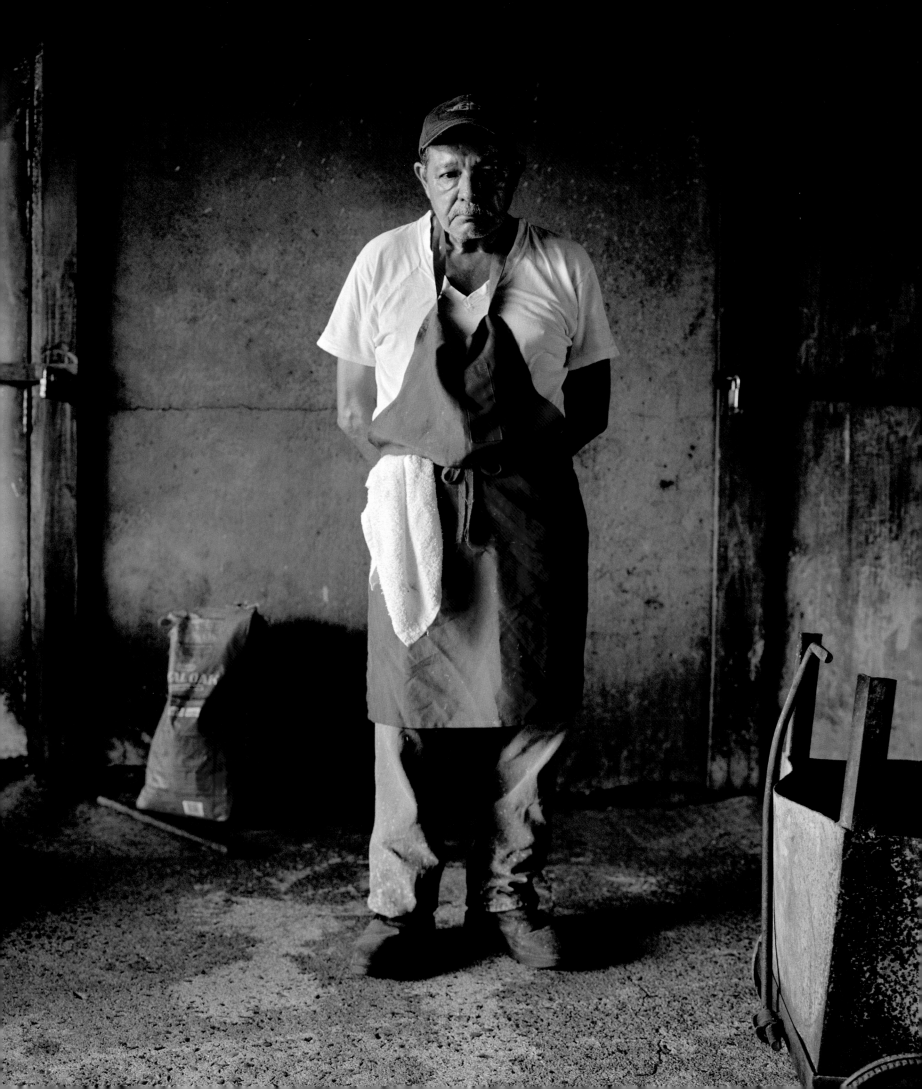

Jessie Hernandez : **DOZIER'S GROCERY, INC.** : *Fulshear*

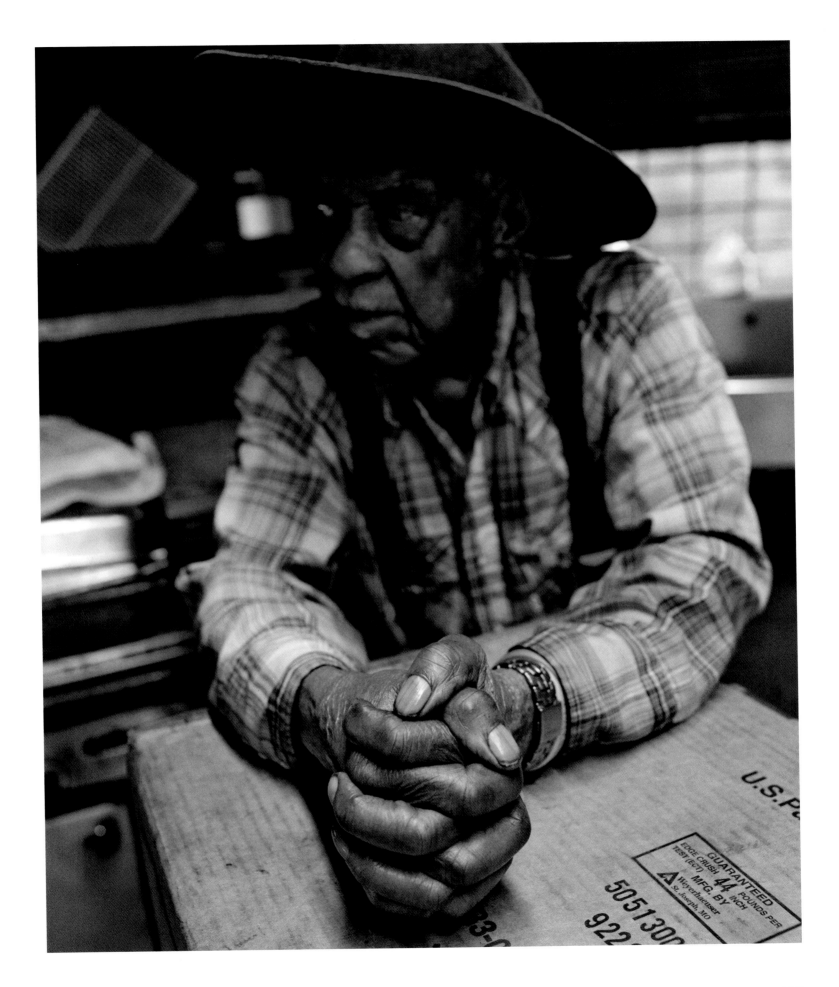

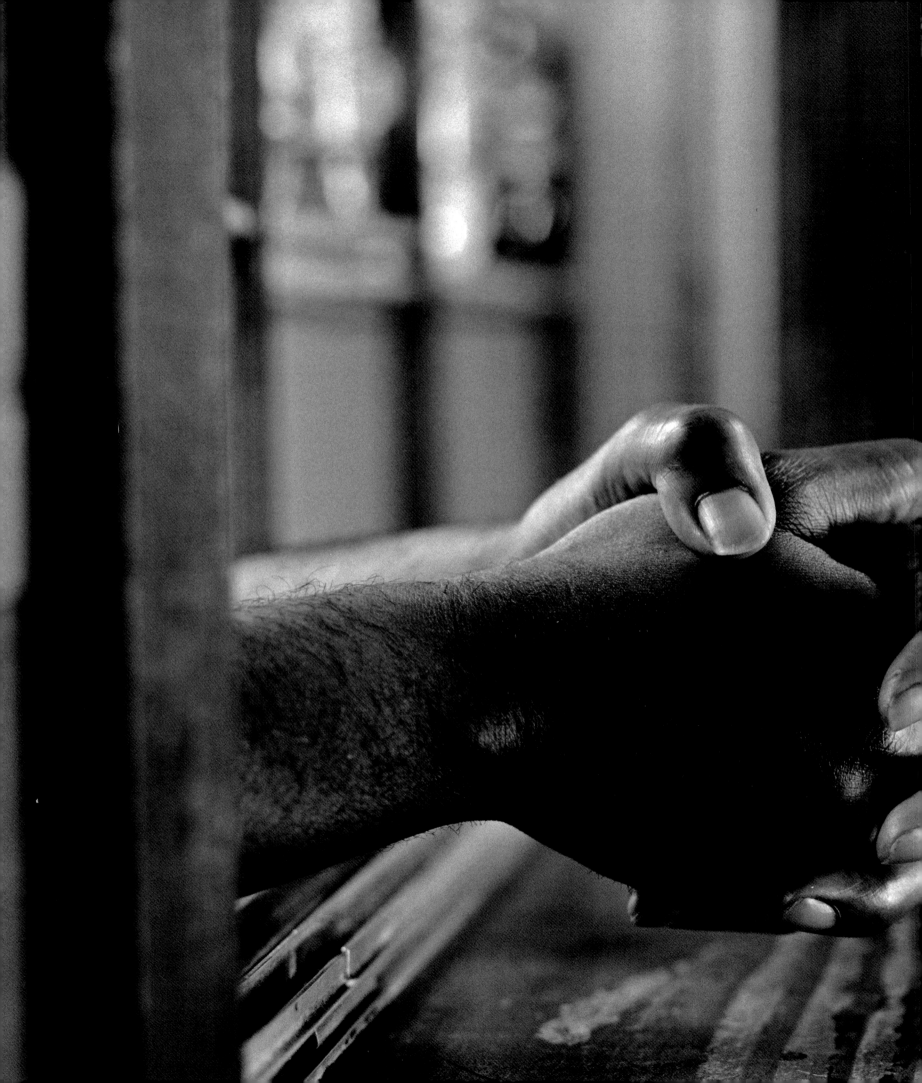

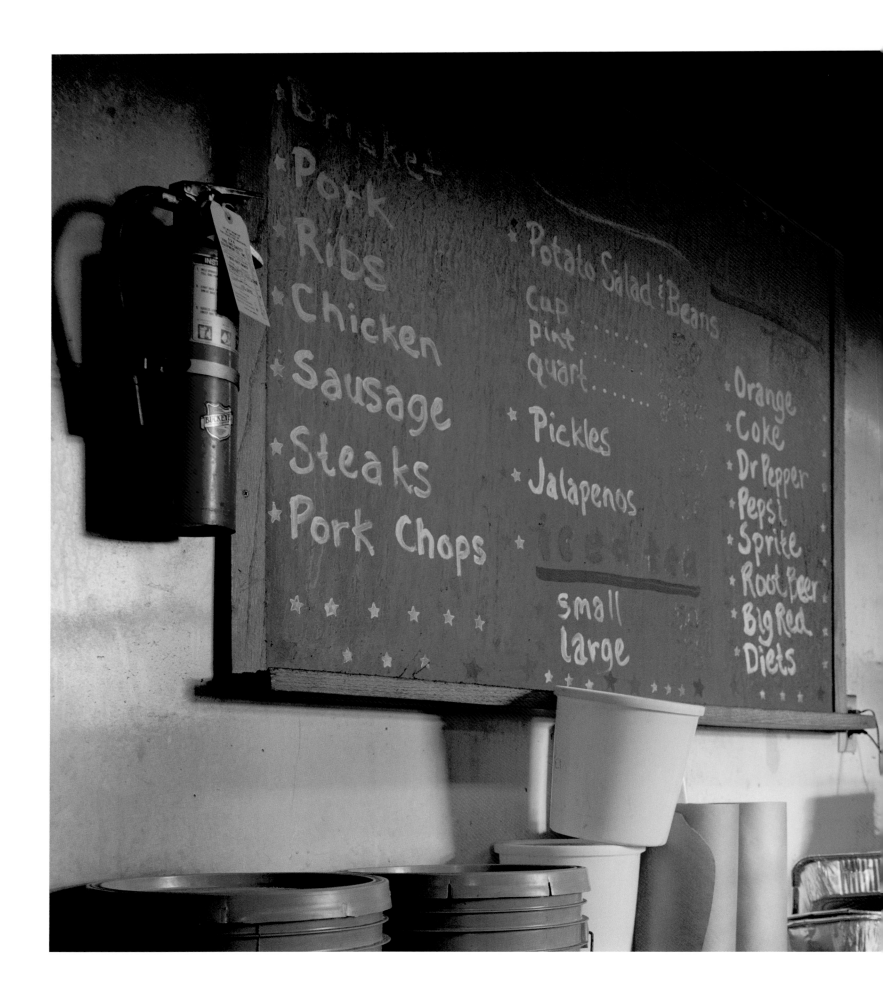

Menu board : **CITY MEAT MARKET** : *Giddings*

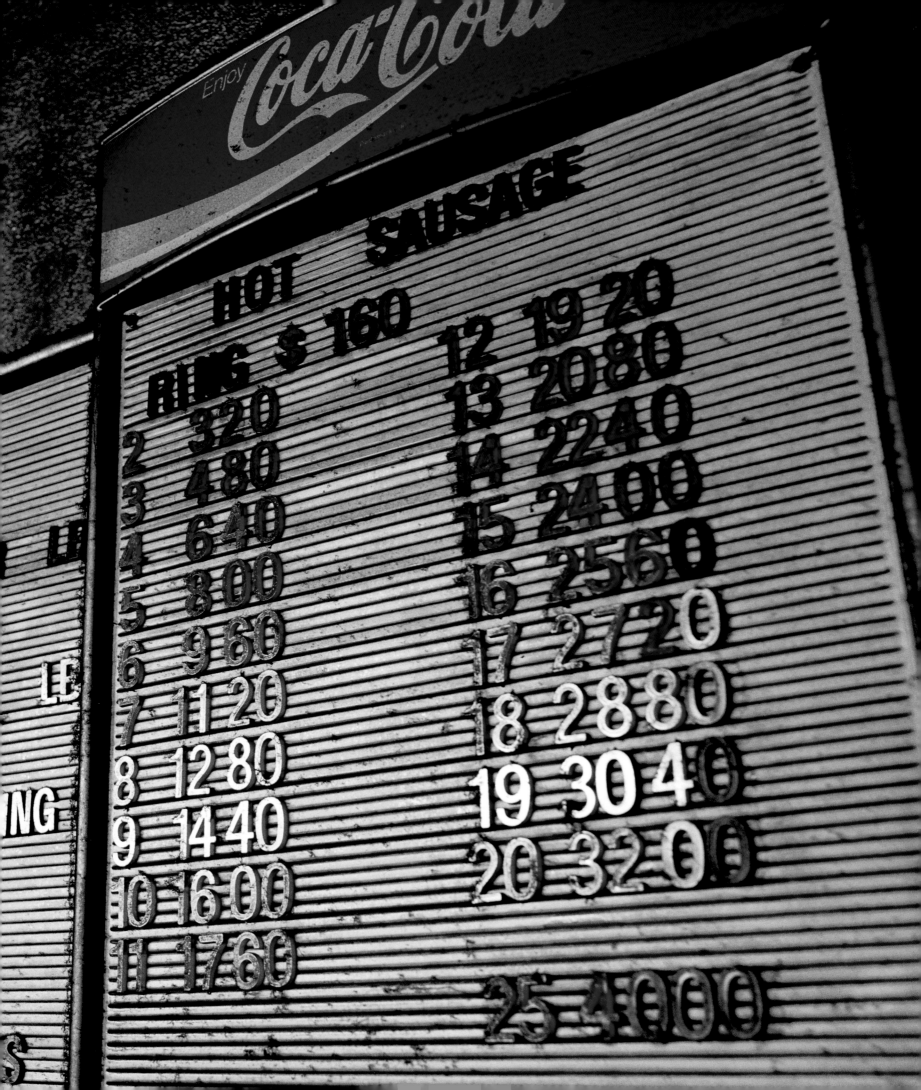

"SEE THAT PAPER? I GET THE BRISKET DONE, AND THEN I GET THAT PAPER WET AND WRAP IT UP. YOU DON'T SEE THAT DONE NOWHERE ELSE, I DON'T BELIEVE. SOMEONE ASKED ME ONCE WHY TEXAS BARBECUE IS DIFFERENT FROM BARBECUE MADE ANYWHERE ELSE. THAT I CAN'T ANSWER, 'CAUSE I AIN'T EVER ATE NO OTHER BARBECUE."

MONROE SCHUBERT, 73, PITMASTER 38 YEARS, PRAUSE MEAT MARKET

Sauce : **SONNY BRYAN'S SMOKEHOUSE** (INWOOD LOCATION) : *Dallas*

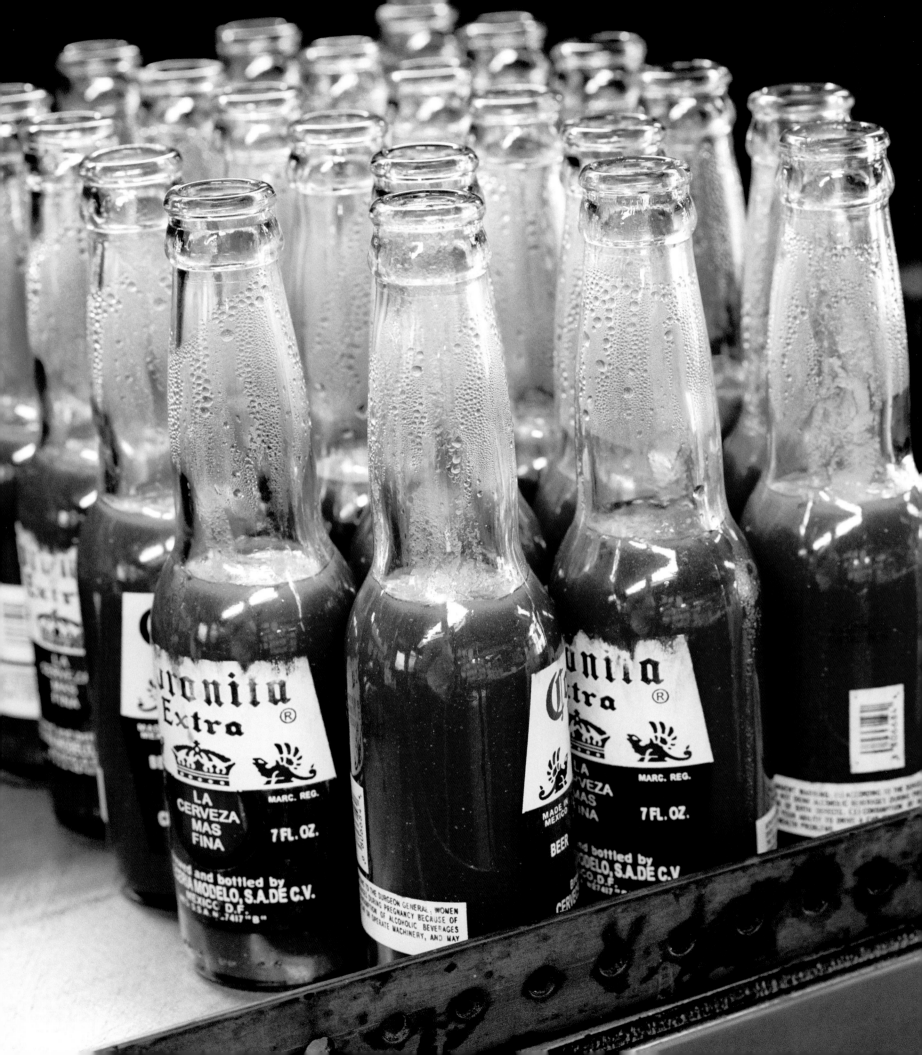

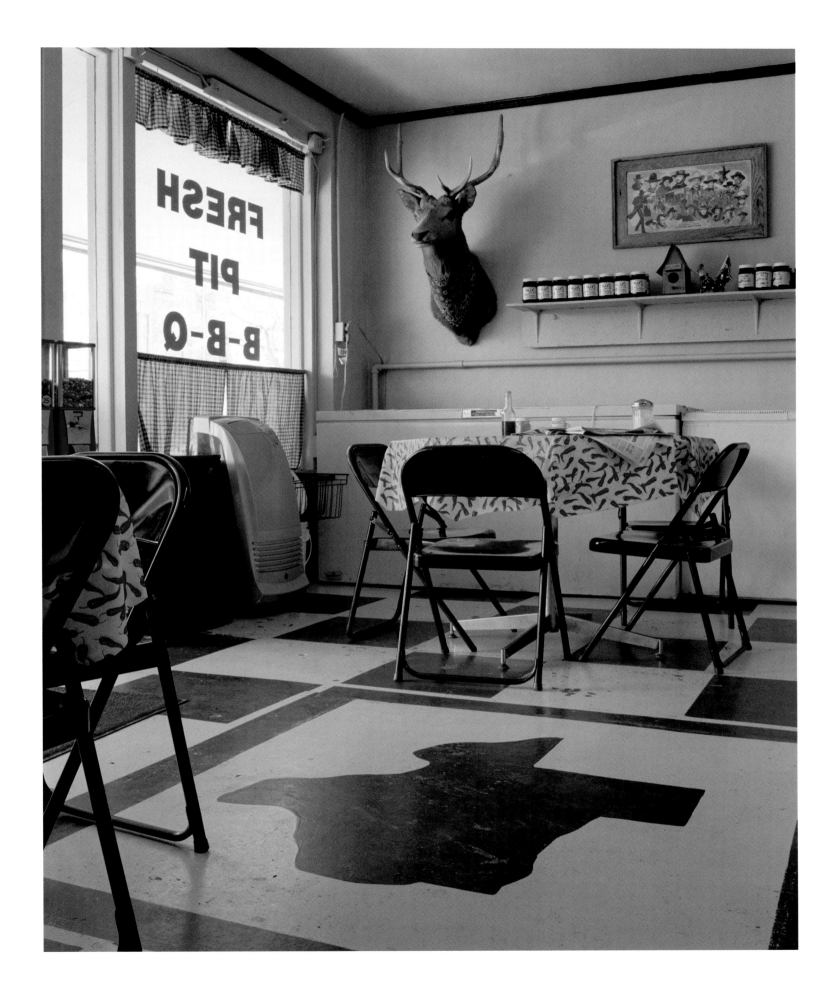

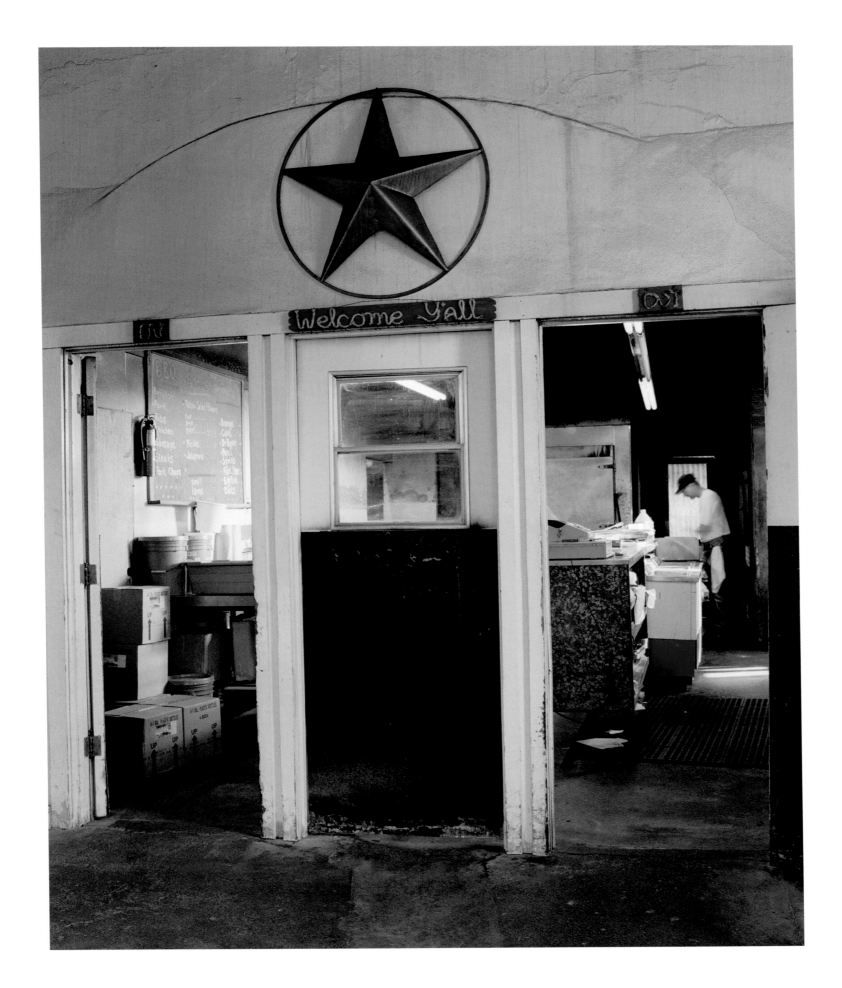

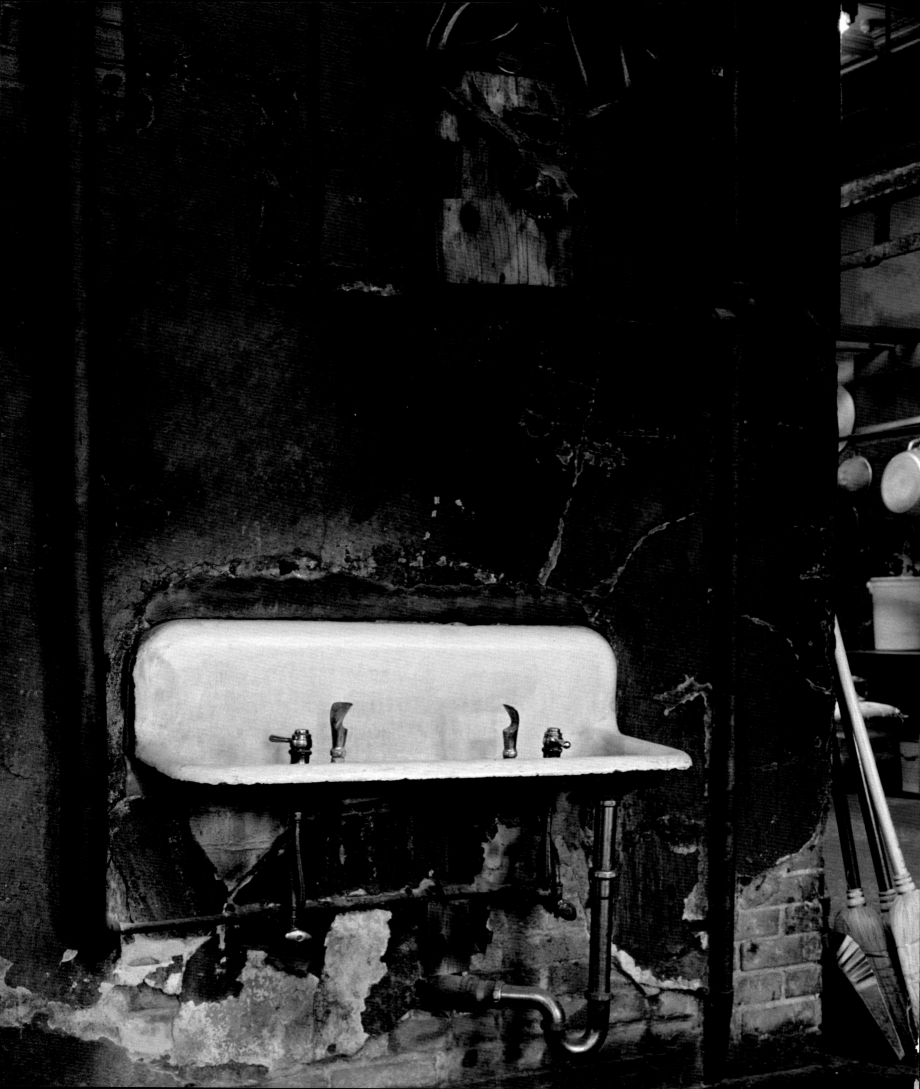

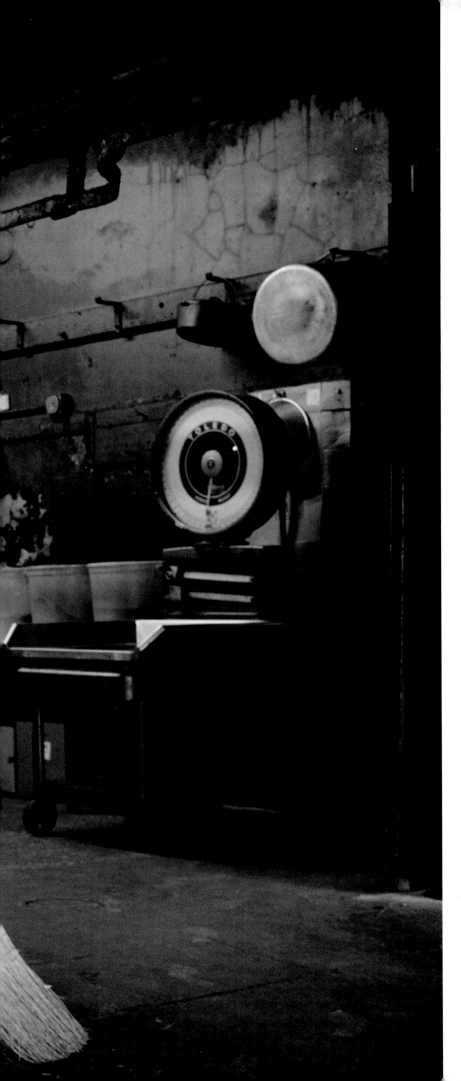

Water fountain : **SMITTY'S MARKET** : *Lockhart*

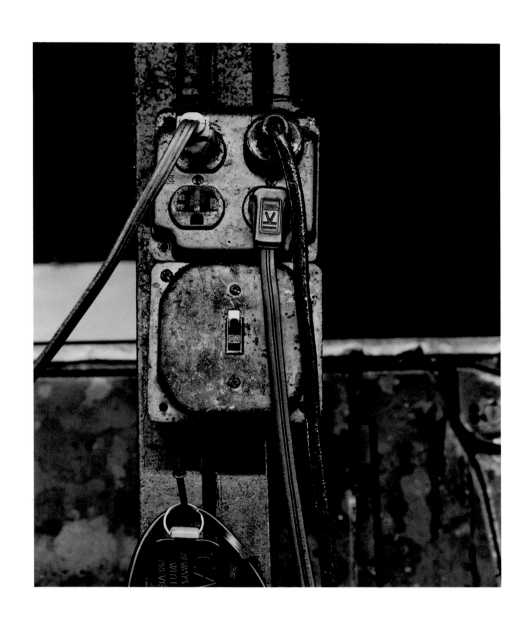

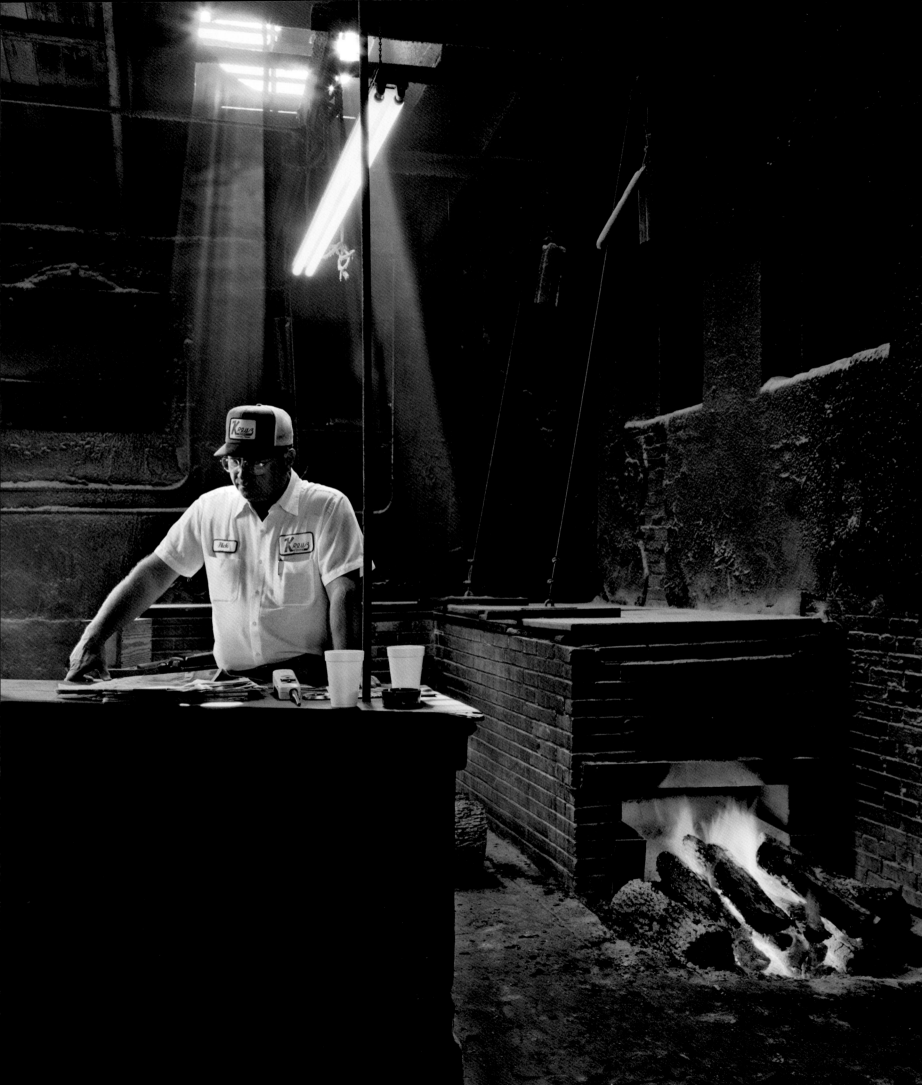

Rick Schmidt : **KREUZ MARKET** (ORIGINAL LOCATION) : *Lockhart*

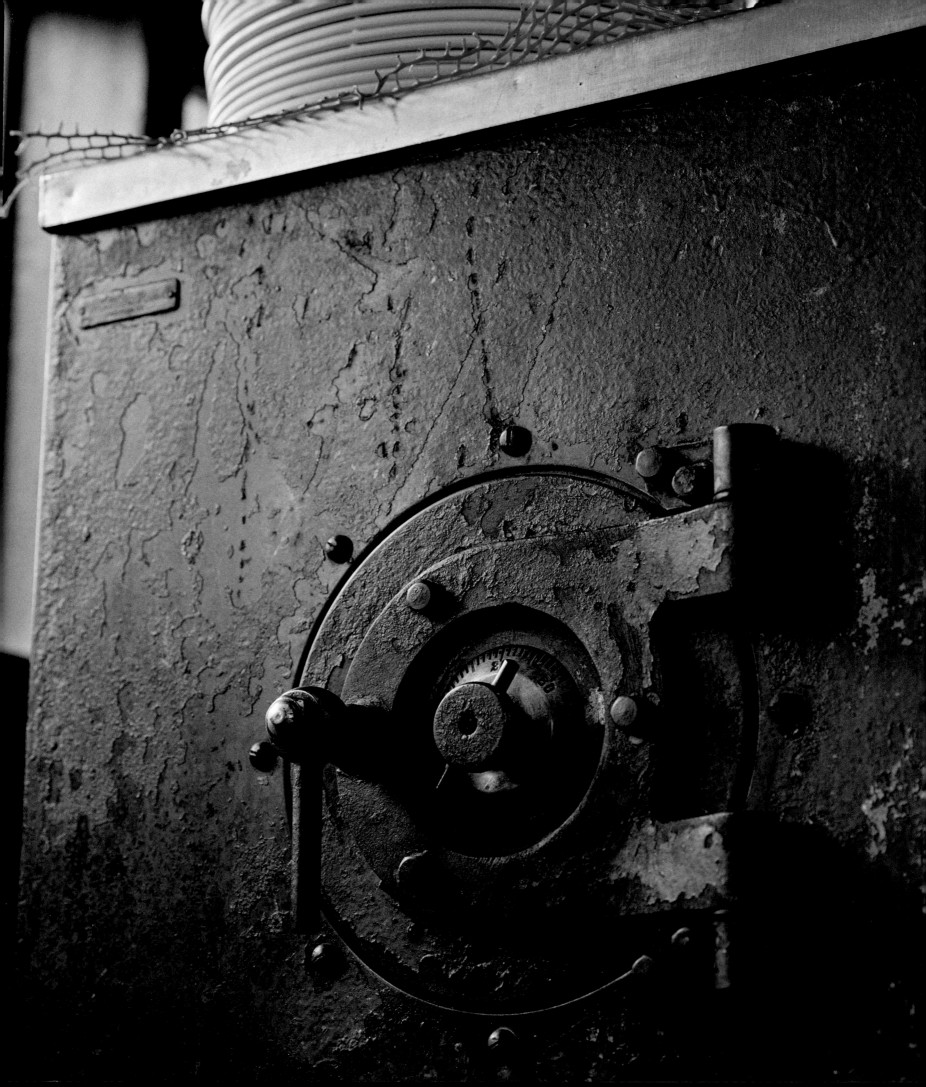

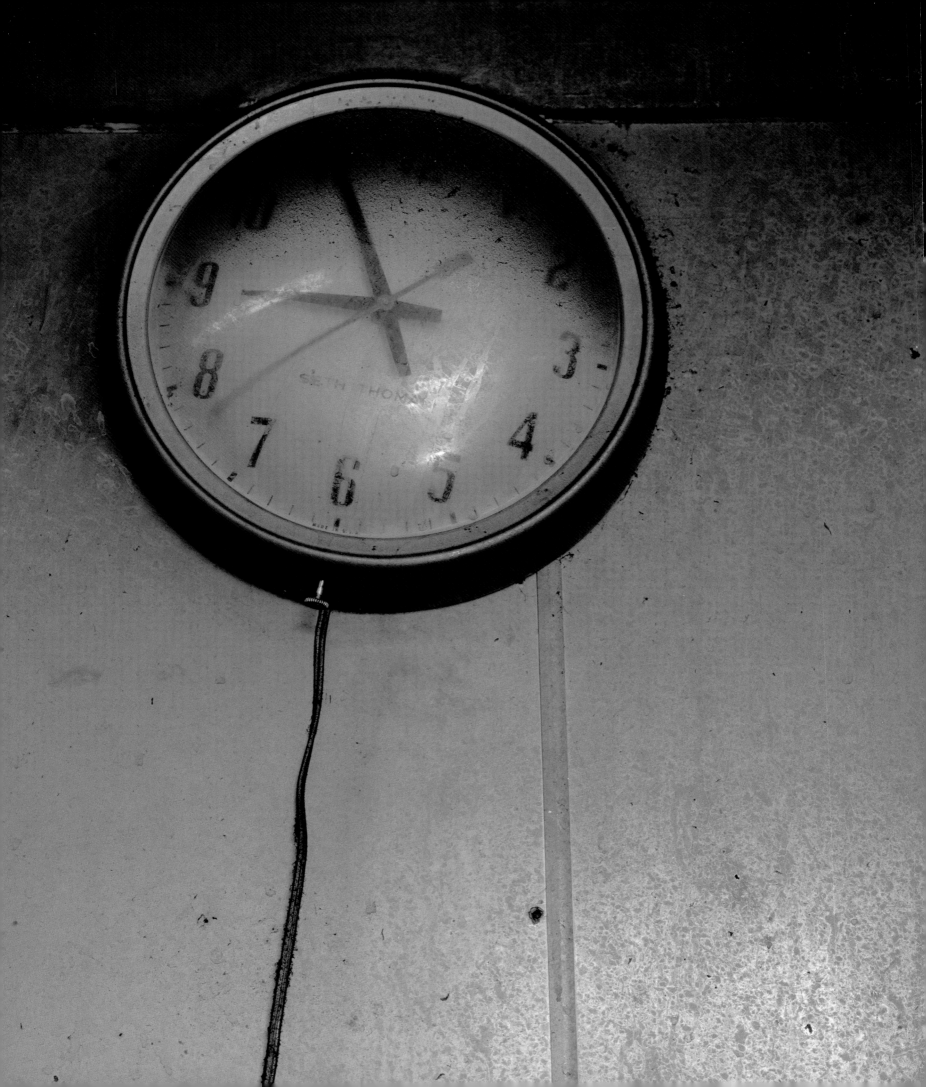

MARTIN'S PLACE

34, 147, 150

3403 S. College Ave.
Bryan 77801
979-822-2031

MAURICE'S REAL PIT BBQ

43, 63, 130

129 W. Veteran's Memorial Blvd.
Harker Heights 76548
254-699-6665

NEW ZION MISSIONARY BAPTIST CHURCH'S BARBECUE

40

2601 Montgomery Rd.
Huntsville 77340
936-295-2349

NOVOSAD'S BBQ AND SAUSAGE MARKET

141

105 S. La Grange St.
Hallettsville 77964
361-798-2770

PAVELKA GROCERY

38

Highway 53
Zabcikville 76501

PRAUSE MEAT MARKET

52, 54, 62, 108, 153, 160

253 W. Travis St. (Hwy. 71)
La Grange 78945
409-968-3259

RUTHIE'S PIT BAR-B-Q

44

905 W. Washington Ave.
(Hwy. 105 North)
Navasota 77868
936-825-2700

SMITTY'S MARKET

13, 16, 68, 81, 144

208 South Commerce
Lockhart 78644
512-398-9344

SONNY BRYAN'S SMOKEHOUSE

23, 30, 47, 139, 157

2202 Inwood Road
Dallas 75235
214-357-7120

STANLEY'S FAMOUS PIT BAR-B-Q

36

525 S. Beckham Ave.
Tyler 75702
903-593-0311

TAYLOR CAFE

33, 123, 127, 152

101 N. Main St.
Taylor 76574
512-352-8475

WILLIAMS SMOKEHOUSE

(Closed: burned December 2007)

128

5903 Wheatley
Houston 77091

ZIMMERHANZEL'S BAR-B-QUE

56, 73, 86

307 Royston St. (Hwy. 95)
Smithville 78957
512-237-4244